COMMISSIONING
ILLUSTRATION

COMMISSIONING
ILLUSTRATION

Martin Colyer

PHAIDON · OXFORD

A QUARTO BOOK

Published by Phaidon Press Limited
Musterlin House
Jordan Hill Road
Oxford OX2 8DP

First published 1990

Copyright © 1990 Quarto Publishing plc

A CIP catalogue record for this book is available
from the British Library.

ISBN 0-7148-2648-0

This book was designed and produced by
Quarto Publishing plc
The Old Brewery, 6 Blundell Street
London N7 9BH

Senior Editor Christine Davis
Editor Lydia Darbyshire

Illustrators Lorraine Harrison, Kevin Faerber
Photography Martin Norris

Design Tony Paine
Picture Research Rachel Withers

Art Director Moira Clinch
Assistant Art Director Chloë Alexander

Typeset by Ampersand Typesetting (Bournemouth) Ltd
Printed in Singapore by
Tien Wah Press (Pte) Ltd

This book contains examples of graphic design
work. These examples are included for the purposes
of criticism and review.

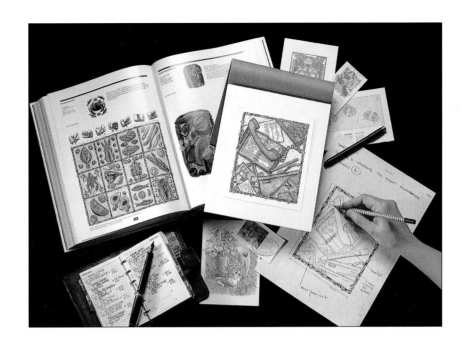

CONTENTS

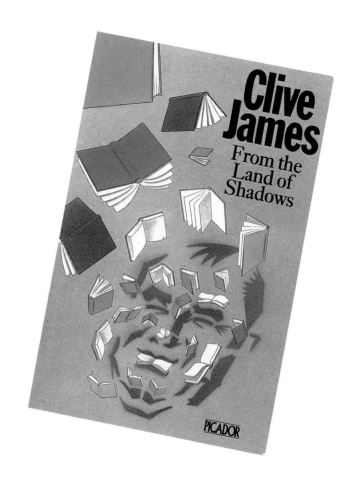

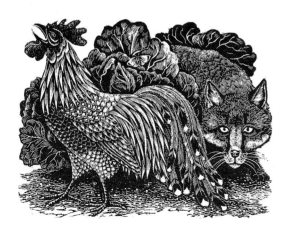

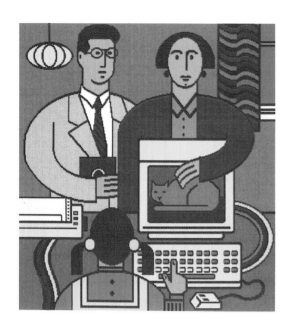

SECTION THREE

USES OF ILLUSTRATION

SECTION FOUR

PRODUCTION AND PRINTING TECHNIQUES

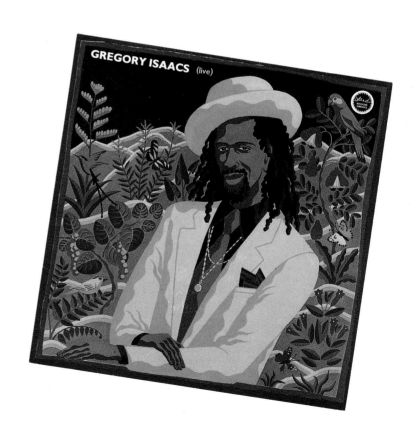

INTRODUCTION

IN A SENSE art-directed illustration has existed for a long time. Before there were magazines, packages, films or even books, artists were commissioned to paint portraits, battles, houses and animals. Chosen by patrons for their style or for their ability to convey drama or to flatter, artists would do their commissioners' bidding.

More recently illustration has been used to decorate, explain and document. It has helped to bring an extra dimension to many authors' words and has given well-loved identities to packages and products that we see every day of our lives.

THE VALUE OF ILLUSTRATION

We have all grown up with illustration. Illustrations hold the key to worlds locked inside the imagination as well as depicting worlds that exist but cannot be seen. When we were children picture books and comics fed us attitudes and information and helped also to develop our visual senses.

The strength of illustration and the almost infinite number of ways in which it can be used have meant that it has not died out or been neglected as photographic techniques have become more sophisticated. Even when the dominant images of our technological age are those we see on film and video, there is something human, something warm, about illustration. It is this special quality above all others that ensures that it will always be part of an art director's armoury.

THE ART DIRECTOR'S ROLE

Illustration illustrates; all illustration is, therefore, art-directed and must work in tandem with a subject and with the design. The function of the art director is to match the concept or the copy with the illustrator who can best visualize it or who can best respond to its qualities. The most satisfying relationship that an art director can have with an illustrator is one in which there is a genuine dialogue between the two as they work on a project, and when the joint input of ideas results in something

Right A cover for *The Listener* magazine done in scraperboard by Bill Sanderson. The brief was no more than the cover line, an article about the technological developments happening in factories based around Cambridge. From that, Bill Sanderson, working from reference of King's College, Cambridge, constructed the image seen on the cover.

THE LISTENER

12 JULY 1984 PRICE 60P (IR £1, USA AND CANADA $1.80)

Cambridge—life in Silicon Fen
John Naughton

John Eatwell Why the pound keeps plunging
Naomi Mitchison in conversation with Leonie Caldecott
Julian Critchley Laying up treasures on earth

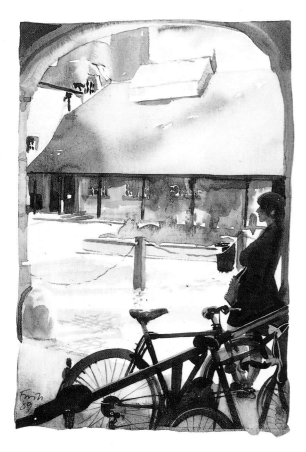

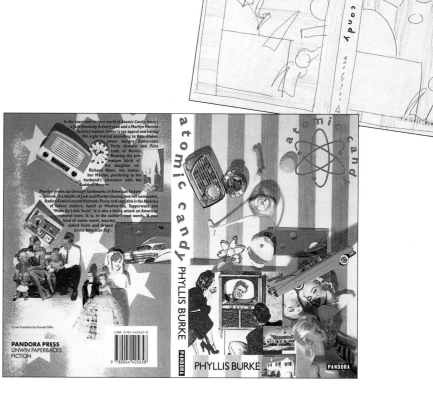

Left A delicate watercolour is the perfect vehicle for a romantic illustration to accompany a magazine restaurant review. The choice of illustration style is a very important factor in creating the atmosphere that a project has.

better than could have been imagined at the outset or than could have been achieved alone.

The age has passed when art directors were often also illustrators. Designers such as Paul Rand, Milton Glaser, Joseph Binder, Seymour Chwast, George Giusti and Tom Eckersley would illustrate their own projects. Some art directors still do, of course, but as graphic design has become an increasingly specialized area, the two disciplines have tended to separate.

Illustrators now express themselves in more varied ways, encompassing an extraordinary latitude of styles in their work. The more thorough your knowledge of the complete range of techniques used by illustrators, the more you will know what is possible, how it may best be translated into the final, printed form and what will work with the illustration in terms of type and layout. You will also be able to talk more confidently with illustrators if you appreciate what they are able to achieve. As an art director you should take the time to learn about the illustration styles that you admire. You should think about why you like them and the response they draw from you.

Above An art director must be able to visualize whether an idea works in its rough form, which can often be very sketchy. Here is the rough of a book cover and the finished item. Obviously in this case the art director knew the illustrator's style and could make the imaginative leap from a pencil rough to how the finished montage would appear when photographed.

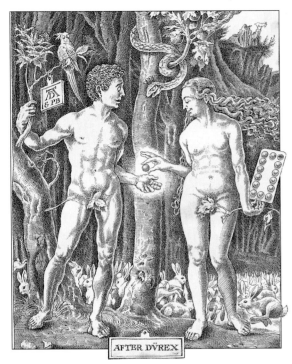

AFTER DVREX

Left Illustrations are sometimes commissioned but not used. This fine drawing by Peter Brookes for a magazine article on the male pill did not see the light of day because the article it went with was never satisfactorily finished. It is one of those dazzlingly simple ideas that has been beautifully executed.

Below Illustration is not often used by car manufacturers, but here is one that breaks the mould, parodying the well-known nursery rhyme.

Right Illustration is a broad church. There is room to accommodate fine line drawing, such as that above, as well as something as bold and modern as this illustration using coloured film, cut and layered to striking effect by Mark Harfield.

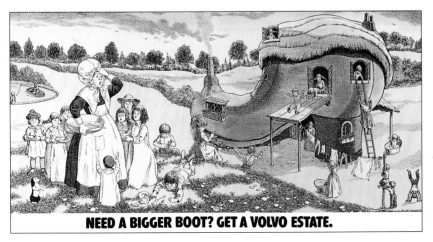

NEED A BIGGER BOOT? GET A VOLVO ESTATE.

Illustration is not, however, just a technical exercise; it is also a very subjective, even emotive, art form. You should be enthusiastic about the work you commission; commissioning illustration should not be a dry, dull exercise, undertaken merely to fill a blank space in your design. When the process works well, the reader or viewer should be unaware of whether the illustration was commissioned to fit into the design or whether the design was devised to complement the illustration. The combination of the two should present a coherent and exhilarating whole.

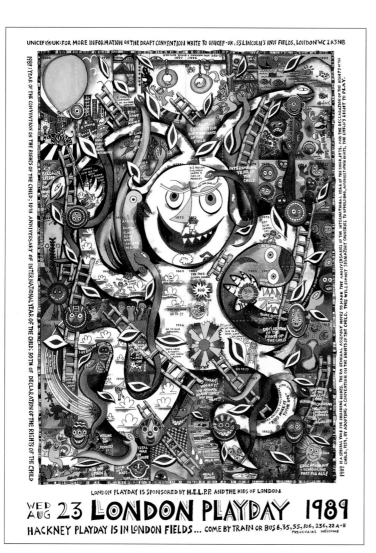

LONDON PLAYDAY IS SPONSORED BY H.E.L.P.P. AND THE KIDS OF LONDON

WED AUG 23 LONDON PLAYDAY 1989
HACKNEY PLAYDAY IS IN LONDON FIELDS... COME BY TRAIN OR BUS 6,35,55,106,236,22 A+B PUSHCHAIRS WELCOME

Left This Playday poster, which was put up on the streets of London, is crammed with the kind of image that would immediately arrest the eye of anyone remotely interested in the subject.

ENCOURAGING NEW TALENT

An important and continuing part of your job as an art director is to encourage new illustrators. Not only does this keep your approach fresh by preventing routine from setting in and so making each job exciting, but it also gives untried illustrators the opportunities they need to develop their skills. There will, of course, be many occasions when you will need to call on the experience and confidence of an established illustrator, but over-conservative commissioning shuts out new talent and denies it the chance to grow. Always remember that today's well-known illustrators were once starting out, taking whatever jobs they could until they found a receptive or innovative art director who was prepared to give them a break.

Above Any art director or illustrator who approaches doing a new version of a well-loved classic must feel apprehensive. This large-format version of *Wind in the Willows*, illustrated by Kate Simpson, has similar characteristics to the original, but adds colour, which is nicely balanced. It also uses the illustrations over whole pages, rather than as drop-ins in the text. This gives a more contemporary feel to the book.

Below One of the Penguin Originals series, an interesting attempt to use illustrations alone as book covers, without the author's name or the book title. The assumption was that you would be curious enough to pick up the book. Although the illustrations tend to be quite graphic, they are often obscure when there is no prior knowledge of the book's contents nor even any clues usually supplied by the title.

Right A National Theatre poster for David Mamet's play about Hollywood agents and writers. The abstract qualities of the collage neatly make up that most arresting of images, a human face. The poster also makes interesting use of colours that are not often put together.

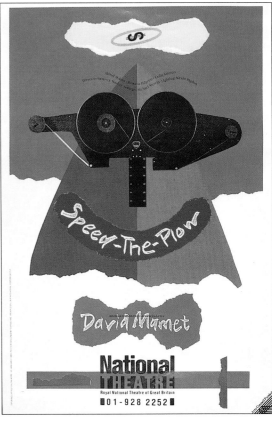

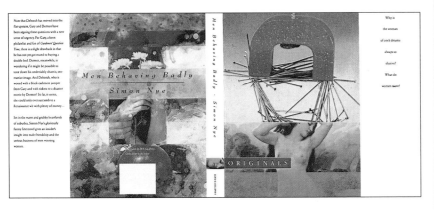

Right One of a series of carrier bags designed for a large chain of stationery shops. The design used simple, three-colour drawings, by Geoff Appleton, making up faces from various stationery products. These images convey at a glance the type of goods sold in W.H. Smith stores.

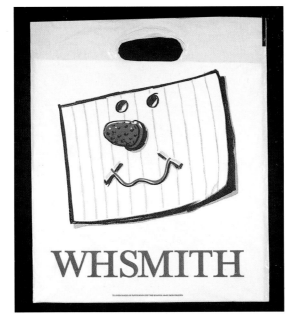

UNDERSTANDING THE BRIEF

It should be axiomatic that all art directors read and comprehend the material for which they are designing and commissioning. Too many designers regard their task as turning out jobs that look pretty or "trendy", or that will impress their peers. Work approached in this way nearly always ends up being about form, not about content.

Nothing in a project exists in isolation: the meaning of the text, its placing, the typeface and the illustration all support and work with each other. Designers should know and appreciate each element of their craft – the typefaces, the techniques, the

images – but these elements are not just individual units that can be moved around until they stack up in one way or another. They are to be used or placed in such a way that they interact and communicate, interest, teach or even move the reader or viewer.

Successfully art-directed illustration should make the fiction that you are reading come to life or, since the advent of designer brochures, even make a visit to the bank more enjoyable (at least visually). The subject should never limit the way in which the design and illustration work. As long as they are appropriate and there is logic behind what you do, there are no boundaries to what you can achieve beyond those which you set yourself.

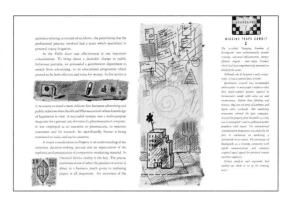

Above A spread from a corporate brochure in which the bold use of illustration helps to make a non-visual subject interesting to read. The whole brochure was lavishly illustrated by a single illustrator.

Right The original of the illustrations shown above. It is interesting to compare the two; the yellow has become more dominant in the printed version, although the rest of the printing is quite accurate.

Left An example of technique being exactly matched to subject. The stark and eerie image uses high-contrast printing and repetition to make its point. The typography is deliberately restrained to let the image do the work.

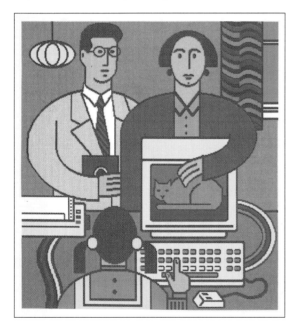

Above An illustration about computers, done on a computer. The image was drawn on one of the "artist" software programs before being output from the machine as four-colour-separated pages (that is, as black and white images). The colour-separation house keyed in the colour as

instructed for each separation with the results seen here. Ironically, the illustration looks as if it had been done in designers' gouache, but it undoubtedly achieves the "computer" effect that was required.

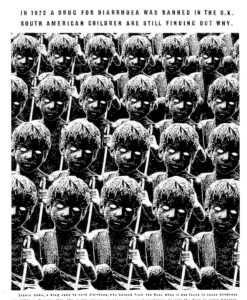

SECTION ONE

THE ROLE OF ILLUSTRATION

WHY ILLUSTRATION?

THE CREATIVE POSSIBILITIES of illustration are limitless. Unfettered by reality, the imagination is free to create images and to conjure up atmospheres. An illustration can illuminate a writer's inner world and give a faceless company a new identity. It can send breakfast cereals to the Milky Way and cut politicians down to size.

In an age when photographs are regarded as the usual pictorial medium, however, art directors will often find themselves in the position of having to convince those not working on the visual side of projects to use illustration.

Everyone can have an opinion about a photograph, but because it shows something that actually *is*, one level of argument or discussion disappears. A photograph of an author, for instance, is either good or bad. An illustration of the same author, on the other hand, has first to pass the test of whether it is a likeness that everyone agrees on; then it has to be assessed on its stylistic merits. People take a photograph at face value and tend not to look much at the detail of the composition. But everything in an illustration has been put there by the artist, so it is easier to criticize – why is that mark there, this object here, and why did the illustrator choose to do *that*? It is these very questions and reactions that sometimes make illustration the more provocative medium.

Some photographers argue that they have un-

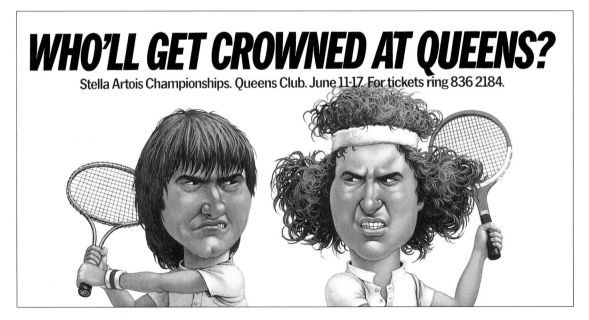

WHO'LL GET CROWNED AT QUEENS?
Stella Artois Championships. Queens Club. June 11-17. For tickets ring 836 2184.

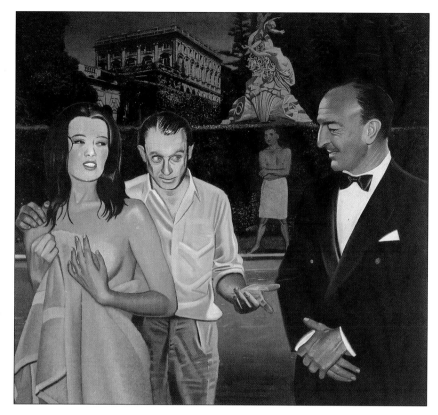

This page A scene that could never be photographed is successfully illustrated by Julian Allen. Complete with characterizations, expressions and atmosphere, it is heavy with hindsight. Strangely, the authenticity of the scene is stronger for not having an airbrushed, photographic reality to it, an approach that often has a very stagey, rather fake quality.

chained photography from its realistic roots, and, of course, they have. Generally, however, they have done this in a way that is more associated with "fine art" than with illustration. Their work has been inspired by their own interests and desires; it is not taken with the purpose of being used as an illustration for someone else's themes, even though some photographs would – and do – make admirable images for book covers or posters.

MORE THAN A PORTRAIT

Situations can arise in which a portrait is required of a person who is unavailable for photography or is disinclined to be photographed, especially for a magazine or newspaper article that is unflattering. Illustration here does not have to be a straightfor-ward substitute for a photograph, simply supplying a painted or drawn version of an image; rather it can be used to add an extra dimension to the article.

An illustration allows you to comment on a person in any way you choose, setting them in any part of the world and in whatever circumstances are needed to convey the point that is being made. The extremities of caricature can provide a fantastical mixture of symbolism, personality and topical allusions. Caricature is not only wickedly funny; it can also be a very powerful weapon.

Illustration is also the obvious medium to use when a person is portrayed in relation to their work or other aspects of their life. It is possible to surround the subject with references that imaginatively tie together strands of his life and work.

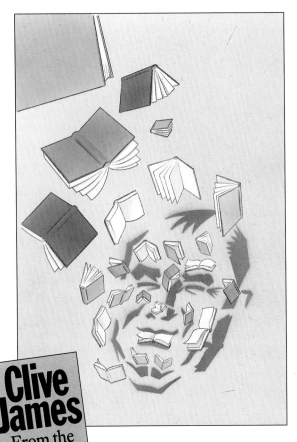

ILLUSTRATOR'S TERRITORY

There are situations where it is difficult to photograph or where photographers are not welcomed. Illustrator Tabitha Salmon, who spent weeks doing reportage work on the UK women peace protesters at Greenham Common, Cambridgeshire, says: "I was met with a tolerance that was most unusual – I'm sure if I'd been working with a camera I would never have been allowed to get so close." The effort involved in drawing in such trying conditions won her the women's acceptance. Similarly, she has drawn throughout the USSR without encountering any of the problems that photographers can meet.

Cameras can be rather obtrusive for work that requires discretion. A small notebook and a deft sketch are less obvious tools.

FINER LINES

Of course, another reason to use illustration is when reproduction is critical. In newspapers, for instance, the predominant images are halftone photographs, which, depending on the quality of the paper's printing, can be very grey. Illustrations are often used to provide a visual contrast; a black and white line drawing makes a graphic statement in a way that yet another photograph does not.

Newspapers often prefer fashion illustrations, with their bold depiction of clothes, to photographs of the same garments, even though some photographic accuracy is lost, because the illustrations print so much better. If an illustration is good, it will convey the line of the clothes in a way that a photograph cannot hope to, especially with its lack of detail in shadowed areas. Perhaps because a garment begins its life on a designer's drawing board, it is somehow fitting that it should finish up again in drawn form.

Drawings of still life objects in newspapers, magazines and brochures are used for similar

This page A book cover that has to include a portrait of a living author is a tricky proposition. Here, Bush Hollyhead brilliantly adds another dimension to a simple portrait. This is one of those images that looks as if it were easily achieved, but in fact, not only is it an extremely good likeness, but it was meticulously planned and executed (note that the shadows forming Clive James's features correspond exactly to the falling books).

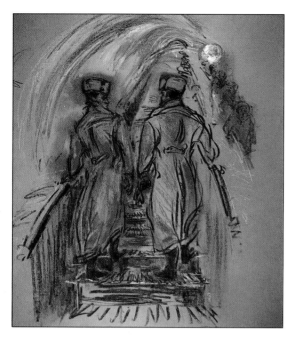

reasons. Not only can they be more detailed and make more impact on a page, they can be used stylistically to unify a possibly unrelated series of objects. They can, of course, also work on a purely decorative level. By providing a change of pace or a contrast, illustrations can be used in a host of ways to enliven a page. Their use is not confined to breaking up blocks of text; an illustration can be printed as a tint under the whole page, or used as a border around the text or to illuminate a headline.

TRAVEL ILLUSTRATION

THERE ARE THOSE OCCASIONS when it is impossible to obtain photographs. A writer may have gone to a far-flung place and returned with not much more than holiday snaps. Using these for reference, an illustrator can often come up with an atmospheric representation of the place.

Above Sadly, reportage illustration is under-appreciated, for the artist's eye and style can be used to excellent effect. This illustration of soldiers on the Moscow underground is from a series on Russia by Tabitha Salmon. She did a tiny sketch on the spot, but it was such a strong image that she had no great difficulty in remembering it when she got back to her studio. She has, in a sense, trained her memory visually, and knows what to look for and how to edit or amplify what she has seen.

Below Michael Terry's illustration of a flying koala bear for a poster advertising Qantas, the Australian airline. A photographic solution to this brief would have been costly, difficult – if not impossible – to shoot and could never have been as charming.

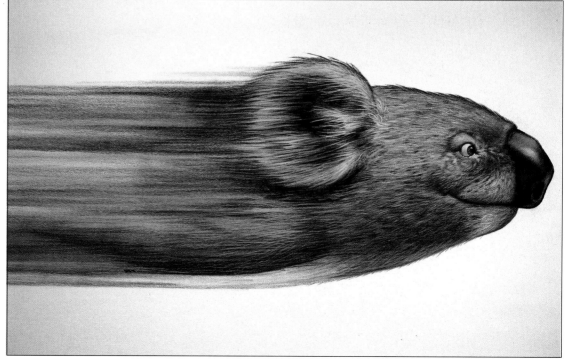

This page This cover for a book on masculinity, scientists and the nuclear arms race is an example of a parody of a familiar image. In this case the allusion is to a World War I poster with its famous copyline "What did *you* do in the War, Daddy?" The father has donned the white coat of a scientist, the daughter asking the question has become an atomic bomb, and the child, previously playing with toy soldiers, is now at a computer terminal playing war games. The use of this image is made possible by the title of the book, *Fathering the Unthinkable*. Also note that the illustrator, Paul Slater, has replaced the roses on the curtains with a radiation symbol and the fleur-de-lis pattern on the chair with silhouettes of bombers. The original poster has been reproduced on the back cover for comparison.

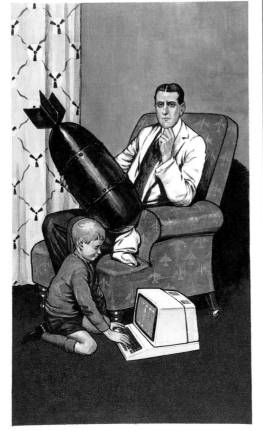

There is also the opportunity to use collage and to incorporate foreign ephemera – whether it be bus tickets, cigarette packets or newspapers. These objects can evoke travel and exotic locations in a way that photographs find difficult to equal.

Asked to provide an image of a harbour to advertise a seaside town, a photographer is faced with certain problems. He will not only have to find the right day (there is a limit to what he can achieve technically with the wrong kind of weather) but also hope to find a suitably atmospheric arrangement of boats as well as the odd interesting "character". An illustrator can not only "control" the weather but also either focus the subject by selecting some and discarding other features of the scene or telescope the events of the day into one drawing, using his sketches or simply his memory.

PRACTICAL CONSIDERATIONS

Many publications and projects are produced on small budgets, and illustration can, without huge cost, add immeasurably to their visual impact. If your budget is low, the expenses for a pen and ink drawing will obviously be less than the attendant costs of photography. This is especially true when you want to create an image that has a period look and that involves people in costume. Not only is the expense of photographing models in a studio notoriously high, but the results are sometimes disappointing, lacking the very realism that was sought and ending up with a rather theatrical look.

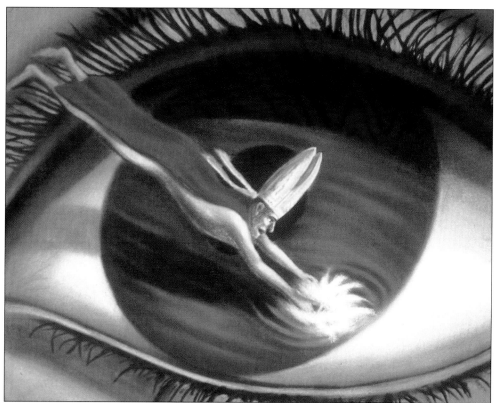

Left This is the original chalk pastel drawing by Geoff Grandfield for a story about an unorthodox Pope. The image is taken from a passage in the book where the main character imagines himself diving into the eyes of a priest. This dream-like scenario was felt by art director Gary Day-Ellison to sum up the tone of the book.

Below The bold black-and-white look of the jacket (one of a series) makes a good frame for the drawing.

ILLUSTRATING THE IMPOSSIBLE

IN STEP–BY–STEP WORK or visuals for encyclopedias, illustrators can focus on specific areas and stages, breaking them down in ways impossible for a photographer to achieve. Illustrators can place the emphasis where they want, using colour or tints to contrast areas and guide the reader through processes. They can cut away, layer by layer, to show how things work, whether it is the human body or a nuclear submarine.

Illustrators can travel back to the Stone Age or far into the future, bringing to life what they see in their imaginations. Illustrations give a sense of vision in a way that cannot be captured by photography. There are no practical limits, only those imposed by the illustrator's imagination.

STYLE AND APPROACH

YOUR CHOICE OF ILLUSTRATION can fundamentally determine or change the look of a project: the illustration on the cover of a book gives readers a set of expectations about what they will find within its pages; the tone of a magazine is set by what is on the front cover. Illustration can also establish or maintain an identity. By using one illustrator consistently or by drawing on a small stable of illustrators, you can give a hitherto bland product a strong, recognizable image.

ILLUSTRATION AND THE OVERALL DESIGN

When initially considering the use of illustration in your project, you have to decide if the *style* of the illustration is paramount. If you have to commission a magazine cover on the subject of "biotechnology and the changing face of science", uppermost in your mind will be the need to find an illustrator who can grasp and visualize such a thorny topic. How the illustration will work in terms of style has to be a secondary consideration. The crucial factor is the illustrator's ability to translate an abstract idea into a magazine cover that will make browsers at a news stand or bookstall respond.

An illustrator may, on the other hand, be chosen expressly because his or her style is perceived to match that of the product. In the advertisement for Rimmel cosmetics shown later (page 26) the ideas are contained within the overall concept and in the copywriting. The illustration simply visualizes the concept and sets an instant and suitably romantic tone. Similarly, an "efficient" look may be required for a leaflet explaining local council services. The desired effect could be suggested by a hard-edged, flatly applied gouache style or by an heroic, monolithic approach in airbrush.

This is not to suggest that stylish illustrations have no content or that stylish illustrators do not include ideas in their work; nor does it mean that good conceptual illustrators have limited styles with which to express themselves. Many people cross over between these two groups.

ACHIEVING THE RIGHT BALANCE

An illustrator who has been working for a decade or more will have a command of the medium and a

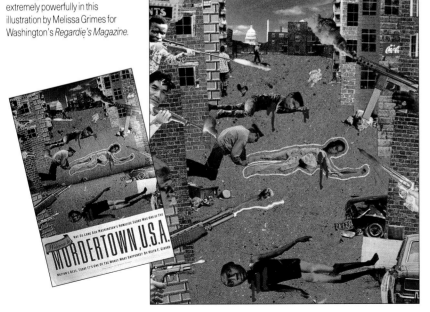

This page Collage is a favourite tool of illustrators who deal with social issues and violent imagery. The dislocated feeling achieved by mutilating photographs works extremely powerfully in this illustration by Melissa Grimes for Washington's *Regardie's Magazine*.

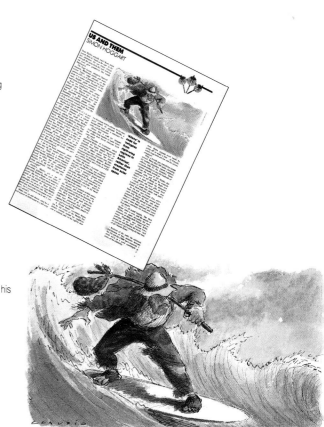

Left Cut-out paper is the perfect vehicle for the subject in Enoke Bakti's illustration for a carrier bag from a children's shop.

Right and above Claudio Munoz uses pen and watercolour in a traditional way that complements his ideas-based editorial work. The simplicity of the layout allows the idea to stand out as the dominant image on the page.

stylistic assurance that is hard to match. Placing this kind of work next to that of exciting, ground-breaking new illustrators will add breadth and depth and give a timeless quality rather than a "here-today-gone-tomorrow" feel to any project. But if older illustrators are totally bypassed in a fad-following obsession to use new illustrators, you will succeed only in narrowing the options that, as an art director, you need to keep open to do your best work.

Alternatively, of course, you should never find yourself relying on a handful of old favourites to whom you turn without really considering the options. This may suit a long-established magazine, helping to give a stable and authoritative feel, but generally it results in a stagnant environment where no new blood has the chance to enter.

Left This kind of "collage" works effectively on computer. As well as having a modernity that comes from the technique, the image has a graphic feel and appearance that derives from George Snow's approach.

The various media

THERE IS A GREAT VARIETY of media, and some people mix them together, either to achieve particular results or because they like working in this way. What follows is a brief description of each medium, with examples showing the range of styles within them.

PEN AND INK

One of the most traditional styles of illustration, pen and ink never falls from fashion, and illustrators succeed in making it relevant to each new generation. The quality of the draughtsmanship is paramount – this is a medium in which poor work is glaringly obvious.

This page Clare Jarrett's stark chiaroscuro pen and ink drawing for a piece on "agony aunts" shows how effective black-and-white illustration can be. It would print well on any kind of paper stock and still retain its drama and impact.

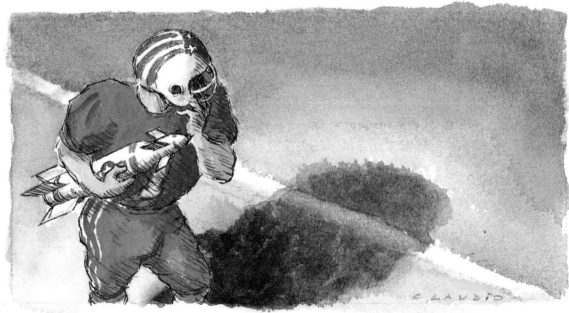

Right Although watercolours were added to this piece by Claudio Munoz, their transparency allows the basic pen and ink drawing to come through. The effect avoids a painterly, or diffuse look that might weaken the idea of the drawing.

Left The subtle shadings of pencil work are in marked contrast to Clare Jarrett's "agony aunts" illustration on page 24, but her choice of medium here works for the subject.

Right Charcoal is a bold medium, suited to large, vivid drawings. This portrait by Colin Williams shows how dramatic its lighting qualities can be.

PENCIL AND CHARCOAL

Illustrators who work with pencil and charcoal generally come from an art school and have a background in life-drawing. Both media have traditional, classic tones that suit a variety of subjects.

Right Many people would regard this illustration for a record cover by Colin Williams as a "traditional" use of charcoal. Nevertheless it sacrifices none of its modern look and feel to his choice of medium.

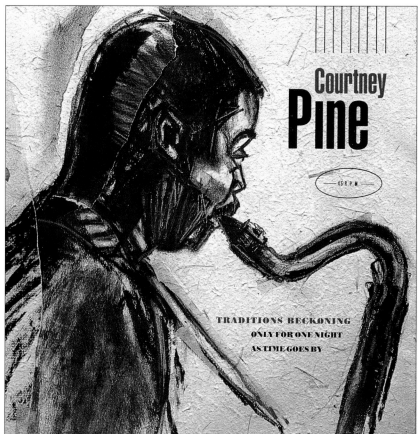

Courtney
Pine

45 R.P.M

TRADITIONS BECKONING
ONLY FOR ONE NIGHT
AS TIME GOES BY

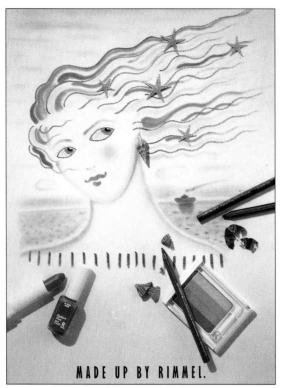

Right Here, the aim was to produce illustration that looks as if it were drawn with make-up, and this was achieved by the use of crayons and coloured pencils.

MADE UP BY RIMMEL.

COLOURED PENCIL

People associate coloured pencil with the post-Hockney school of Glynn Boyd-Hart and Adrian George, although its use now is much broader. The colour can often be very strong, with rich tones, but it retains the sense of "drawing", which you do not get with gouache or pastels.

PASTEL

Often a medium associated with soft, dreamy illustrations, pastel can, in fact, be used in many different ways. Its deep, pure colours are at the same time rich and "dusty". It is not a medium for small details: you will find that most people who use pastels will produce large-scale illustrations.

WATERCOLOUR

Watercolours tend to be used in a traditionally evocative way, their translucent quality creating an open, light feel. They are generally not used for highly detailed work.

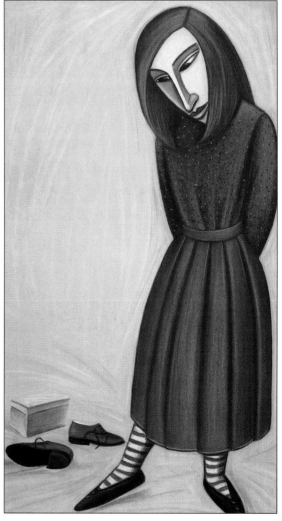

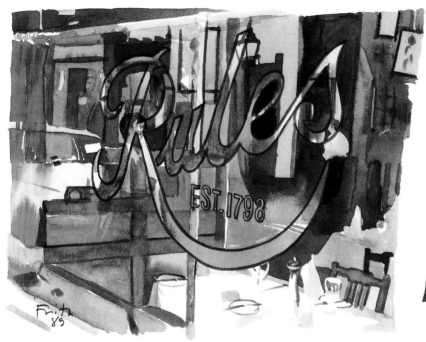

Left and below Michael Frith's watercolours for the restaurant column of a magazine are loose, painterly studies with a spontaneous, atmospheric feel. He also has the ability to handle detailed elements – the reflecting restaurant name, for example – without disturbing the overall look.

Left The colours found in the aptly named pastel range suit certain subjects perfectly. Amanda Hutt's rather melancholy reflection on buying shoes perfectly suits the tone of the article it accompanies.

Left and below David Holmes' illustration shows precisely what makes watercolour illustration unique – the simplicity and subtlety, the dabs of colour bleeding into the water and even an evocative hint of times past.

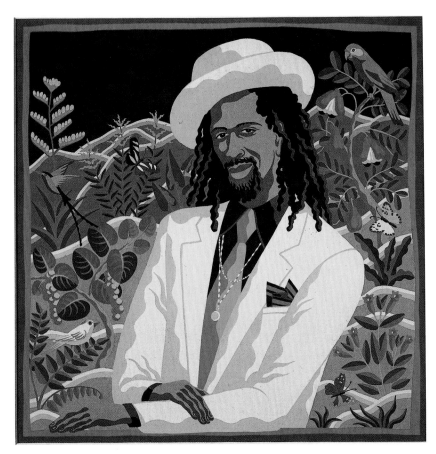

GOUACHE

A very "designer" medium, gouache can give a satisfyingly clean result and reproduces well. The paint enables the artist to cover large, flat areas with blocks of colour in a way that is difficult with acrylic or oil paints.

ACRYLIC AND OIL

Acrylic paint, which is used in a "painterly" way, is a popular medium because it is so versatile. Acrylic can mimic the translucent look of watercolour as

Above A gouache illustration by Linda Gray of the singer Gregory Isaacs shows all the best reasons for using this medium. The colours are not only satisfyingly deep and opaque, but they work extremely well together, pushing forward the figure in the foreground.

Right Gouache is used here in large, flat areas to give an almost cartoon-film-like look to the illustration. On the man's face, however, the gouache has been used more like watercolour.

Above A painting in acrylic by Paul Slater for the cover of the *Sunday Times Magazine*, where the "look" required was of an 18th-century painting. The malleability of acrylics makes then an ideal medium for replicating this look in time to meet a short magazine deadline.

well as being the user-friendly cousin of oil paint. Acrylics are extremely quick drying, unlike oil, which takes so long to dry that it is often impracticable, even when deadlines are generous. However, the fact that oil paint is very slow to dry means that extensive re-painting or mixing can be carried out.

AIRBRUSH

Originally designed for photographic retouching, airbrushing is used for illustration when a highly polished, glossy look is sought. It is often used in conjunction with other media by illustrators at the more graphic end of the spectrum. Airbrushing requires a high level of skill, and poor masking and technique are quickly apparent.

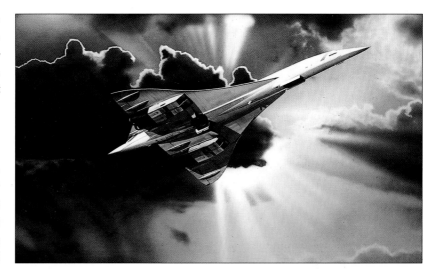

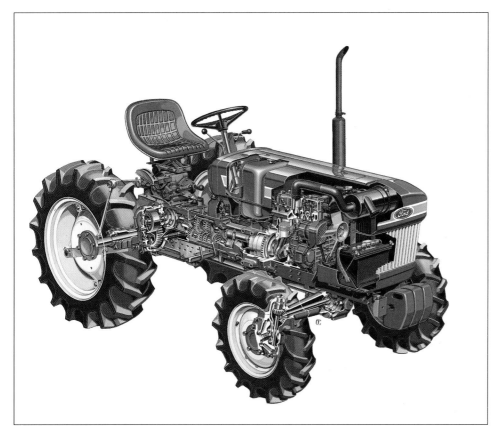

Above Airbrush is often the preferred medium when illustrations of technology are required. This is a particularly good example because it combines sharp technical detail with an evocative skyscape. The skyscape is done in a more freehand way than the tightly masked illustration of the aircraft.

Left A highly detailed piece of technical airbrushing, in which not only is the mechanism of the tractor drawn with stunning realism, but the actual bodywork and paint finish are equally well represented.

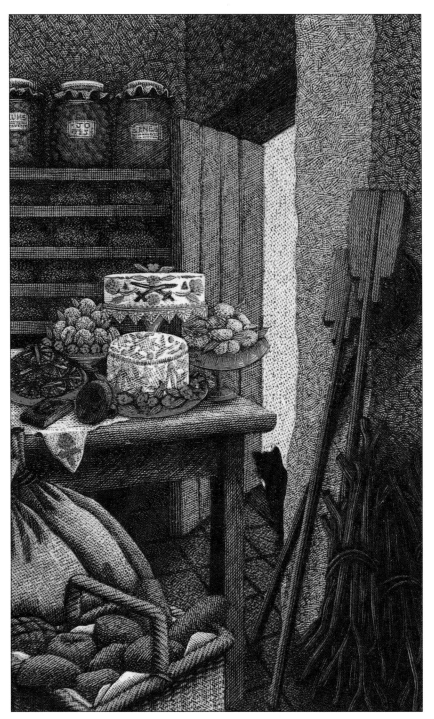

After being out of fashion for a long time, woodcut and engraving have experienced something of a renaissance lately. Once regarded as part of the craft movement, they are now seen as a vibrant branch of illustration, mixing charm and delicacy with graphic boldness. Perhaps their only limitations are that they are fairly lengthy processes, unsuited to short deadlines, and that only a few people have mastered the skills to the fullest. Even fewer illustrators work in colour than in the customary black and white.

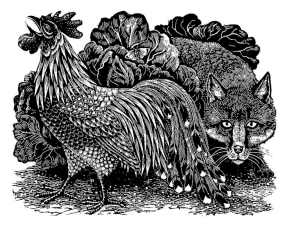

Above Black and white woodcuts, which are often small, draw heavily on the tradition of artists such as Thomas Bewick and are well suited to traditional subjects, such as that illustrated here by Sue Scullard.

Left and right A book cover by Edwina Ellis in the old technique of wood engraving. The detail is breathtaking, and the colours are vibrant. It was done with three blocks, and the cakes, the focus of the illustration, were deliberately centred under the title panel.

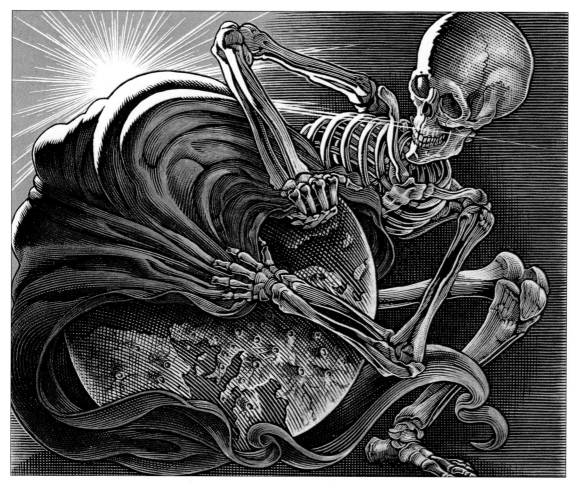

SCRAPERBOARD

There are few practitioners of scraperboard, which is a shame as, used well, it is a dynamic medium. Ink is applied to the surface of the board, which is then scraped away to leave a black line image. The drawing is therefore done in reverse, in a similar way to an etching. Paint can also be applied and scraped away, and transparent inks are sometimes used to colour in the white areas.

Some scraperboards are not peelable, and transparencies must, therefore, be used if the work is to go on a scanner.

COLLAGE AND CUT-OUTS

Collage became fashionable in the 1960s because of its Pop Art and comic book connotations, and it has always had strong links to fine art. These continue today, and collage is often used to give an "arty" look to projects.

Cut-outs are dramatic and graphic in their effect, but the impression they create can be changed significantly by the choice of coloured paper. They are also very flexible in scale, holding small details even when radically reduced. Cut-outs can also be produced by using coloured films such as Letratone.

Now that most colour separation houses are moving over to laser scanners, which require artwork to be flat and flexible, colour transparencies of both collages and cut-outs must always be made.

This page Four images that couldn't be more dissimilar but that have a common feature – all are layered or collaged. Clockwise from left: a striking use of hand-coloured, Xerox-distorted images; coloured Letratone, built up and used in a very "painterly" way; a three-dimensional model, painted, drawn and assembled; and, **above**, a simpler collage, using tones of grey to give a hand-done, craft feel.

COMPUTERS

The fad of equating computers with futuristic images has subsided to some extent, but at the same time the creative scope is expanding. There are more programs and more sophisticated equipment to give illustrators access to an extraordinarily wide range of techniques. However, the most interesting work in this field is not achieved by using the computer to mimic other media but by using it as the drawing instrument itself.

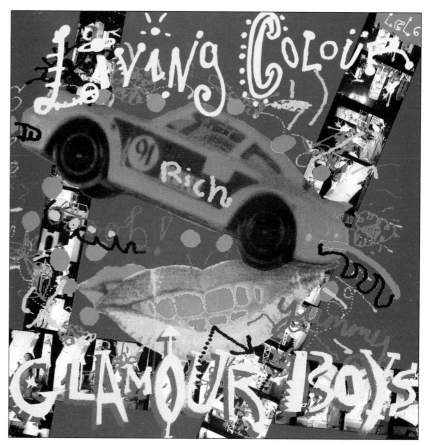

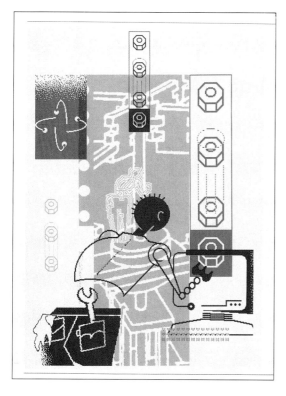

 Left This three-dimensional model by Lesley Saddington was painted, drawn and assembled for use in a two-dimensional magazine. The image retained its depth when printed and had the desired theatrical effect.

Above Using computers such as the Apple Macintosh and their drawing programs results in layered, graphic work.

Above and left Work that could have come only from the video and computer age. Paintboxes and similar tools allow images to be manipulated and colours shifted almost indefinitely, and the results are difficult to generate in any other way. George Snow (*Illustrators* cover, left) has been working on machines, first a Xerox, then a computer, for years. The Thunderjockeys (record cover and inner sleeve, above) grab images from everywhere for their illustrations.

THE ROLE OF THE ART DIRECTOR

THE ART DIRECTOR is generally the person in the middle. Occasionally he or she may be the sole instigator of a project, but in most cases the editor or the client is on one side, while on the other is the illustrator. The art director, therefore, has to act as the conduit of intent and information between the two, interpreting what the client or editor wants and commissioning the appropriate illustrator to visualize, or flesh out, that concept.

INTERPRETING THE BRIEF

Of all the skills required of an art director, interpreting the brief can be the most taxing. He or she has to be able to fillet a complex article and present it in a cogent, concise way to the illustrator. The art director has also to be ready to discuss various ideas intelligently with the illustrator, as good decisions are rarely made in a vacuum. Similarly, talking to the editor about a piece not only reveals the editor's own feelings about and insights into it but can also fuel new thoughts. Everyone's ideas are there to be used, and it is the art director's job to harness and channel them. Once the illustrator understands what is required, he or she can embellish all these ideas and add a personal view.

The other major drawback to the preconceived approach is that it does not allow for any input from the illustrator. That is fine if you are hiring someone for their style above all else, but otherwise you are missing out on half of what an illustrator does: to realize ideas and concepts with visual flair.

Commissioning an illustration and reacting to it

once you see it is a much looser, less disciplined way of working, but for certain projects it can add a life and variety that set them apart. This approach also works well for routine jobs, when you are more or less doing the same thing week in week out. It is a way of varying your own approach, making it more interesting for you and also for the illustrator who has an opportunity to work without constraint.

An art director should know a wide range of illustrators and be aware of their capabilities, their strongest areas and which of them might fit in best with the concept of the whole piece.

Finally, it is also necessary for the art director to be widely read and to have a good general knowledge. It is essential that he or she is familiar with what has already been done in the field of design and illustration and also is able to think in a broad way about concepts and approaches.

WORK BEGINS

THERE ARE TWO WAYS to approach a brief. An art director can start out with a finished result in mind or a firm idea of the style of the finished piece; alternatively, he or she can commission an illustration and react to it when it is finished.

There are no rules to say that you should not approach the project with a clear perception of the finished illustration in your mind. Sometimes you get an idea in your head that is difficult to get away from, and this becomes, for you, the "perfect" way to do the job. The difficulty inherent in this approach, however, is that the "perfect" illustrator is

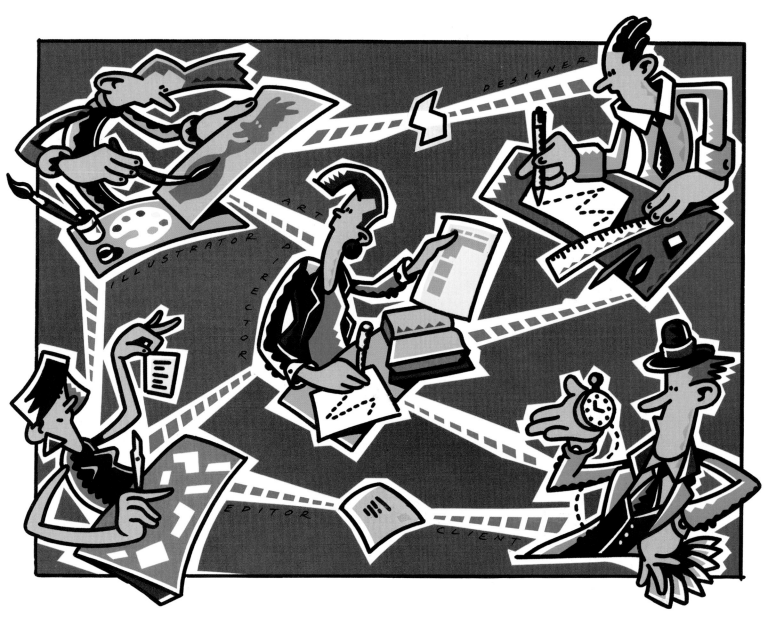

part of the package, and if he or she is not available, your plan ends up in the wastepaper basket.

You can, of course, start to look for an alternative illustrator, but this usually means that the "perfect" approach is already compromised. You have to alter the way that you view the finished result because the worst thing you can do is to try to shoehorn an illustrator into an ill-suited, preconceived package.

It isn't a perfect world: rarely does everything fall into place. You can find the perfect illustrator to work on a job that they really want to do, and things can still turn out differently from your expectations.

Above The art director is at the hub, drawing together all the strands of a job. He or she is commissioned by the editor or client, and in turn commissions the illustrator and/or designer. In this situation communication becomes an invaluable skill.

SECTION TWO

FINDING THE RIGHT ILLUSTRATION

FINDING THE RIGHT ILLUSTRATOR

WHEN YOU ARE SATISFIED that you understand the brief, your next task is to find an appropriate illustrator. As art director, you should make sure that you build up a filing system of established and new illustrators whom you could approach.

LOOKING AT PORTFOLIOS

The best way to understand how illustrators work is to see their portfolios. When you begin to do this you will be faced with an incredibly wide variety of presentation: there are those people whose work is slickly presented in immaculate folders with a

This page A typical portfolio, from the illustrators' agency The Organisation, shows a mixture of work, some originals, some printed.

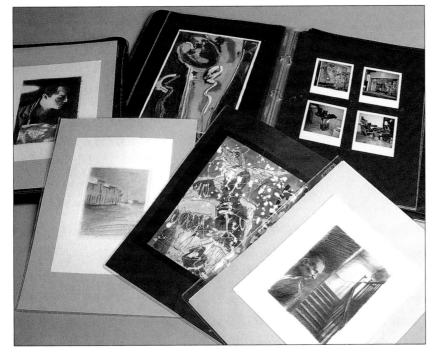

portable slide show, and there are illustrators whose one folder is bulging with paintings and whose pockets are stuffed with notebooks. Good presentation is helpful, but it is not everything.

Showing a portfolio should not be the monopoly of students or of unestablished illustrators. It can be a revelation to see the portfolio of someone who is in demand. It will contain pieces that you probably will not see anywhere else: their personal work, jobs done for in-house brochures or publications or work published overseas. You will also be able to see how they approach briefs and discuss their work with them. These discussions can often lead to areas that will be of use to you as you find out their interests and the ways in which they ideally would like to work. It is always worth keeping in touch with people whose work you admire but with whom you have been unable to work for whatever reason. Seeing their portfolio every six or nine months will keep you abreast of what they are doing.

Inevitably, illustrators become pigeonholed. If someone starts off doing drawings of computers, because that is what their first commissions were for, other art directors who need computers drawn will often see them as "specialists" and offer similar jobs. Some art directors have faith only in work that has been printed, rather than in the more varied work that is in the illustrator's portfolio. This can be the start of a vicious circle, and many illustrators find they are not given the chance to show what they can really do. As an art director you should stop to think that they might appreciate a different sort of com-

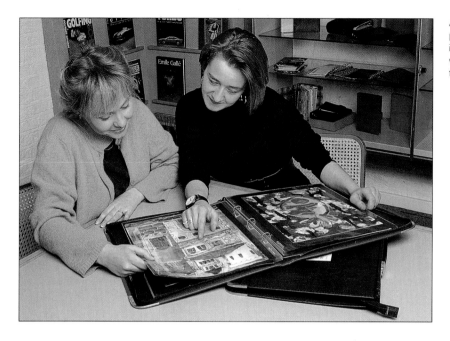

An art director looking through the portfolio. Personal contact is important, and establishing a rapport with an illustrator enables you both to do better work.

mission, a different sort of challenge. Very often illustrators will rise to the occasion when someone shows faith and commissions them in a more adventurous way.

While you are looking through illustrators' portfolios you may see a piece of artwork to which your first reaction is "I wish I'd commissioned that". Be careful that you do not then try to "reproduce" it by giving the illustrator a similar job. It is always best to be excited by what an illustrator may do for you in the future rather than by something from the past.

PRACTICALITIES

In my experience illustrators phone constantly to book appointments. I find it easiest to set aside the quietest day of the week and to see, on average, eight illustrators, allowing about half an hour for each. Some illustrators will talk at you a mile a minute as you flip through the pages of the portfolio; others will hardly say two sentences. Either way, this is a fair amount of time for them to show their work to

its best advantage and for you to gauge their commitment to their craft.

Some art directors, especially in large companies, use a "drop-off" system whereby illustrators leave their portfolios at the reception desk to be studied at the art director's leisure. Sometimes comments are added for the illustrator to read when the portfolio is collected. Although this method means that you do not waste time looking at a portfolio that is of no relevance, you lose out by not making contact with the illustrator and having the portfolio explained.

You will find that August and September are particularly hectic times, as students who have just finished their degree courses descend on you. You should always remember that this is an important interview for them, and you should make an effort to make it as relaxed yet as informative an experience as possible. And never forget that you owe it to yourself to see as many students as possible – in every batch you are sure to find a few illustrators whose work really excites you.

General Questions to Ask Illustrators

- What is your background?
- At what speed do you work? (This is especially relevant for complex techniques.)
- What are your interests?
- If you are not local, do you have access to a fax machine?
- Who are your regular clients? (This is not relevant to students.)
- Whose work do you admire?
- Where do you feel your strengths lie?

Keeping files

THERE ARE SEVERAL WAYS to keep track of the illustrators you see. Most will have some form of personal card – anything from a home-made lino cut or a colour photograph stuck on board to an extremely elaborate, glossy, professionally colour printed sheet or brochure. You may find it useful to keep these for quick reference in a series of books with plastic pages.

For a more detailed record of their work, especially if it covers a wide range of styles, it is worth photocopying a selection. When you come to look through these copies you will often find that there are aspects of the work that you have forgotten.

This page A promotional booklet sent out by Benoit Jacques to show the different types of commissions that he has handled, along with his (often very funny) comments about them. It is a fairly lavish affair, printed in full colour.

Make sure, too, that you have some colour reference, not just black and white photocopies. Some illustrators will have colour samples of their work in the form of tear sheets or simple colour photographs. A more expensive way is to shoot polaroids, but the print size restricts the usefulness of this.

You can usually file your reference material into categories such as fiction, information, natural history, technical drawing and fashion, but this is not always practical. Many illustrators cannot easily be defined by subject area, although, if you are prepared to spend the time, you could file them in more than one section.

Your filing system will depend on what kind of work you are commissioning, and it is impossible to say how your system should work. It really does depend on trial and error. The end result is to have a system that enables you quickly to locate the right illustrator for a particular job.

ILLUSTRATORS' PUBLICITY MAILERS

From time to time some illustrators send out small booklets. These may be simple, sometimes witty, change-of-address notifications, or they may be personal projects that the illustrator wanted to see printed. Occasionally an illustrator may have been given *carte blanche* on a professional job and been so pleased with the result of the project that an extra hundred copies were run off. These giveaways are always interesting because they let you see something that the illustrator has, in effect, commissioned him or herself. This insight may inspire you to use them in a new way.

flouting the established rules of the game, and, despite his neglect of the bunny-rabbits and the haystacks which so distinguish the medium, he tries to make a living as a Wood Engraver.

Peter Forster was a free-lance illustrator in the 1960s until he joined the Department of the Environment, Ancient Monuments & Historic Buildings, which became English Heritage in 1984 and from which he resigned in 1985. Forbidden to to use Wood Engravings in publications (his Civil Service Boss pronounced "Wood Engraving is old fashioned.") he took it up again in his spare time as an artistic therapy and went in for mild satire because it was refreshingly anti-estab-

lishment. He set up the Malaprop Press, so named because his spelling is as erratic as his proof-reading is ship-slod.

He has exhibited with the Society of Wood Engravers (of which he is an elected Member), the Printmakers' Council, the Royal Society of Painter-Etchers and Engravers and the Royal Academy. He has

illustrated for the Folio Society, the Fleece and Libanus Presses and for the Observer. He is interested in colour Wood Engraving and is producing a suite of caricatures called *A New Temple of British Worthies*. He is, as these illustrations may indicate, a miniaturist.

A PUBLICITY VIGNETTE

PETER FORSTER
WOOD ENGRAVER

THE MALAPROP PRESS
1986

Right Home produced on his own press, this vignette, complete with sardonic biographical details, introduced the work of Peter Forster. From booklets such as this you can gain an impression of an illustrator's approach and commission to the strengths you see.

VISITING GALLERIES AND DEGREE SHOWS

The last few years have seen a great expansion in the number of outlets where illustration can be seen. Illustrators can now have exhibitions in the same way as fine artists, and this is obviously helpful to art directors, who find themselves invited to private views. They are always worth attending as you can see a wide range of work in its original form.

Degree shows are more of an unknown quantity. The results can be very exciting or rather disappointing, but in a couple of visits you can see work by all the new illustrators about to enter your world, so it cannot fail to be a useful exercise. Remember that, during their courses, illustrators can be asked to try their hand at graphic design. Their efforts in this field do not always match up to their illustrations, so it is worth looking beyond the presentation of the work.

Take a notebook and write down the names of those illustrators who catch your eye together with a brief reminder of their style and subjects. These things are easily forgotten once you have seen more than two shows.

Left An invitation to a college illustration show. Most art directors are on college or institute mailing lists, as well as those of galleries that show illustration, so invitations come as a matter of course.

Agents

IT IS DIFFICULT TO GENERALIZE about agents. Some come totally between art director and illustrator: all communication is carried on with the agent firmly in the middle – you explain the brief to them, discuss the fee and then wait for the first roughs. Others step out of the way once the introductions are made.

Agents will deliver portfolios to you, usually on the day you speak to them. They will also visit you with a general folder, showing the range of their illustrators, and provide glossy folders or files with a couple of colour pages devoted to each illustrator they represent.

Your approach to agents will depend on the area in which you work. Art buyers at advertising agencies prefer to deal with agents, because knowing ten agents is a passport to hundreds of illustrators. Also, as they need to please clients outside their own organization, they feel that an agent offers security and relieves them of a certain amount of pressure.

This page Agency cards and posters are extremely useful at-a-glance aids. They are not comprehensive, though, so you should build up extra reference for illustrators whose work has impressed you.

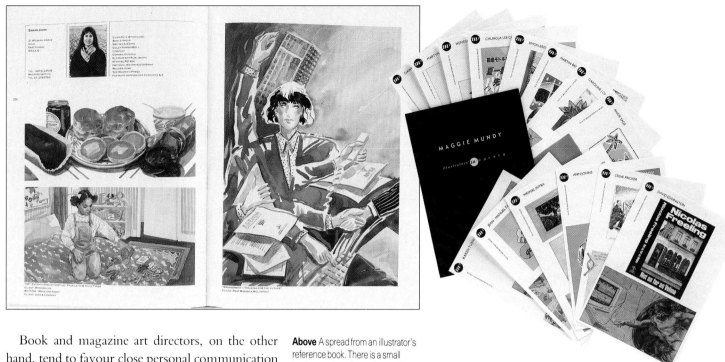

Above A spread from an illustrator's reference book. There is a small background caption and space for three images or more to give an impression of the styles that the illustrator works in.

Above An agent's pack. This is more useful than the posters as it has more examples, often showing the work as it was used. Packs such as this are usually printed in full colour.

Book and magazine art directors, on the other hand, tend to favour close personal communication with illustrators, often limiting their dealings with agents to discussions about money. Design groups generally fall somewhere between these two. They have outside clients to satisfy, but are often more open to the idea of discussion with the illustrators.

Be wary of agents. If the illustrator of your choice is not available, they may try to persuade you to commission their second-string. This is usually someone on their books who is not as good or not as experienced, but who works in the same style. You will now find yourself in a difficult position: you have to reassess your whole concept with a deadline looming. The disappointment at losing your original choice may make you grasp at straws, and whether you succumb to this approach will depend on how important the individuality of the project is to you.

STOCK ILLUSTRATIONS

Library illustrations portraying celebrated people, great events and social situations can be obtained from many sources. The Bettmann Archive, the Hulton Picture Library, the Mansell Collection and the Mary Evans Picture Library are all fine sources of engravings and drawings from centuries past. Their old-fashioned style can often be used successfully to complement modern, newly commissioned illustrations. However, these sources are generally used more by picture researchers than by art directors.

Some modern libraries have stocks of illustrations on various themes, but it is hard to imagine that this is a creative use of illustration or that your individual project will be best tackled by using these vague, bland images.

Looking around you

AS ART DIRECTOR you have a duty to yourself and to your company to keep abreast of new trends and developments in illustration. In addition to seeing portfolios and visiting exhibitions, you must be prepared to use every source that is available to you.

SOURCE BOOKS

Illustrators' annuals provide an excellent summary of images from many fields, although their selection policies can be somewhat arbitrary. They range from work by experienced talent to that of students who are just starting out. Remember, too, that they are always at least one year out of date and styles develop and change. You may find yourself choosing an illustrator because of the medium he or she works in. You may, for one particular idea, want something to look like a painting and you may have chosen an illustrator because of what you saw of their work in a year book. Always check that they are still working in the style you expect.

On the other hand, if your approach is fairly flexible and the elements that initially attracted you to the illustrator – the handling of difficult subjects, their sense of humour, for example – are still present, it is possible that they will persuade you that their new style will work.

OTHER SOURCES

The boom in illustration has made banks, billboards and bottles into canvases and every supermarket into a potential gallery. There is no better way to keep in touch with current work than to notice these everyday things as well, of course, as the more obvious vehicles such as magazines and book covers. Get into the habit of looking at things around you as an art director rather than as a consumer. Develop a critical sense: work out how things were put together, whether the idea and the execution tally, how well the piece has been printed. If you like an illustration but do not know who it is by, it is easy enough to telephone the manufacturer and get the name of the agency or design group, which will tell you. Magazines or books generally carry a credit for the illustrator.

LOOKING ABROAD

PEOPLE ARE OFTEN DETERRED from working with illustrators from abroad because they fear they will not have sufficient control. My own experience is that this is not so if your deadlines are long enough.

Below There are now more illustration yearbooks available than ever before. Most countries publish selections from every medium on an annual basis. Graphic design annuals, such as *Design and Art Direction* (UK) and the *New York Art Directors' Annual* (USA) also have illustration sections.

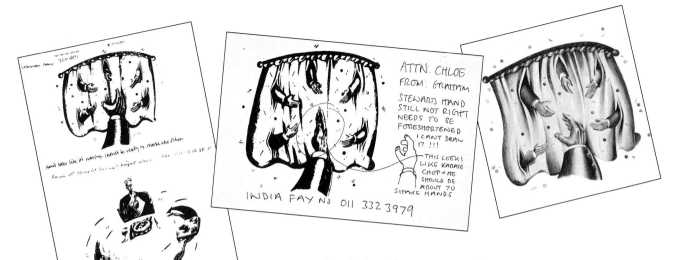

Advances in technology have made it easier to work with illustrators who are not based in the same country as you. Easier telecommunication links, especially the advent of facsimile machines, have meant that roughs can often be shown to you or the client more quickly than they could be brought to your office by an illustrator working in the same town. A rough involving a great deal of colour cannot be shown to you in this way, of course, but the efficiency of courier services means that the job is rarely more than a day or two away.

A more important problem of working with illustrators from abroad is lack of communication or misunderstandings resulting from language or cultural differences. Briefs have to be more explicit and avoid highly topical references and the kind of "short hand" terms you might use with a local illustrator. The brief should also include detailed information about anything peculiar to the country featured in the illustration. A US illustrator, whose style was perfectly suited to the subject matter, was recently asked to illustrate an article on motorway madness in the UK. He was furnished with reference material for British police cars and road signs, and in these his work was perfectly realistic. What the art director did not notice, however, was a bus which was entirely American in design.

TALKING TO OTHER ART DIRECTORS

YOUR FELLOW ART DIRECTORS are another source of information about illustrators. Apart from the obvious difficulties of talking to people from rival publications or to direct competitors, it is a good way of finding out talents they have come across. You can also learn which illustrators they trust and their experiences of working with them. Their methods may bring out different aspects of the illustrators' skills from the ones of which you are aware.

Many art directors willingly pass on illustrators' names or suggest that illustrators go to see other art directors or design groups. The illustrators they recommend are generally those they consider to be of a standard that is similar to that of the art directors concerned. In theory, this creates a sort of circle, which, it is hoped, helps to raise the general standards of design and illustration.

Above A job in three stages done via a fax machine from India. The illustrator's rough (**far left**) includes his written explanation of the ideas. The rough (**centre**) was amended and the hand re-drawn, and this has been marked by the art director with a visualization of the way the hand should be drawn. The final piece of colour artwork (**right**) was then prepared.

Interpreting the brief: the illustrator

BRIEFS VARY. Some are extremely explicit, requiring an illustration to slot into a pre-determined role; others are not much more than a synopsis and a size. In both cases it is the illustrator's job to provide something that *works*.

Professional illustrators should be aware that a commission from an advertising agency for a drawing promoting a wine shop requires a different approach from an illustration for a magazine article on wine. They should not expect to turn round to an advertising agency and say "I've got a better idea!", even though they can do exactly that to a magazine art director.

A heavily art directed brief may require only a little interpretation of the ideas by the illustrator. If the project is an advertisement, for example, the idea will have been generated and visualized by the copywriter and art director and approved by the client often before an illustrator has even been approached. The illustrator's task is to come up with

Right The art director had worked with a particular illustrator for this travel company before and, as the company felt his style suited it, wanted him to do the cover for this brochure. The designer did a marker rough, using examples of the illustrator's work for style reference but putting in the elements required by the client. The illustrator faxed the rough (**far right**) to show how he would actually draw what the designer had sketched out. The designer's and the client's comments are written on this copy. Changes have been made to some of the elements – the sneakers were replaced by a map and compass, and the sunglasses by a camera and postcards.

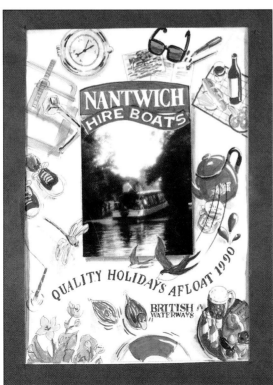

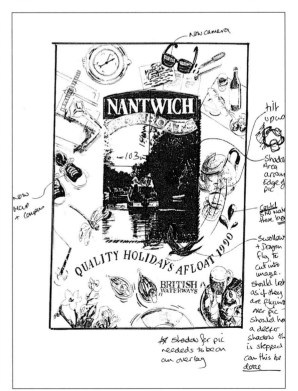

the required image and style.

When the brief is loose, however, the illustrator's input is far greater. The art director may suggest the general course the illustrator is to follow or may even just set the parameters to work within. If a piece of fiction is to be illustrated, the art director will have read the piece but may not suggest any particular angle, leaving it to the illustrator to weigh up and judge the story and come back with suggestions about what aspect of the story should be illustrated. Art director and illustrator can then discuss whether they agree and take it from there. This approach works with good illustrators because one of the reasons they were chosen was for their skill at visualizing characters and storylines.

Only experience will tell you which illustrators can cope with being given a loose brief. Some people feel set adrift if they are not told what to do, and they work best when they are heavily art directed. Others find it hard being directed at every stage of the project and are happiest when they are working from their own, or from mutually conceived, ideas.

However, the illustrator's input is crucial. Not only would it be difficult for the art director to come up with ideas for every illustration, but the results would be extremely boring. One person's view is limiting, and it is the collaboration between art director and illustrator that makes for the most varied, interesting work.

Right A final fax was sent to check the amendments and the positioning of the images and lettering.

Right The finished artwork, airbrushed onto white board, is ready to go to the printer. Note that sufficient image area has been left to allow for the printer's bleed requirements, although not much space in the case of the blueprint, below the barometer.

Above The printed cover. The colour is quite accurate, and very little in the way of design has changed since the first marker rough.

Facts and figures

HAVING DISCUSSED THE BRIEF and selected the appropriate illustrator, there are several technical points you must bear in mind and make sure that your illustrator understands too.

SIZE

You must always remember that certain styles of illustration are suited to certain sizes of reproduction. You will find that some people only produce small pieces of work while other illustrators work to a very large scale. It is always a risk to try to convince someone that they must change the scale of their work for the job you have in mind.

If you do not know the size that the illustration will ultimately be reproduced, you must make sure that the artwork is larger than the largest possible finished size of the illustration. If the artwork is quite small but the illustration needs to be larger, the coarsening effect of enlargement can damage the effect of the illustration. Illustrations generally work best when they are reduced.

REFERENCE MATERIAL

It is usually the art director's responsibility to provide any reference material that an illustrator needs, and you will often have access to a picture research department. If you are commissioning an illustration of someone that is based on photographs, it is wise to get the widest possible selection. Black and white photographs are useful because people can work, in daylight, with them next to their drawing boards. Colour shots are also neces-

Right An original illustration and the printed job featuring it. With black-and-white line work (especially the bold strokes used here), well printed, you can be sure that even a large reduction won't cause any problems.

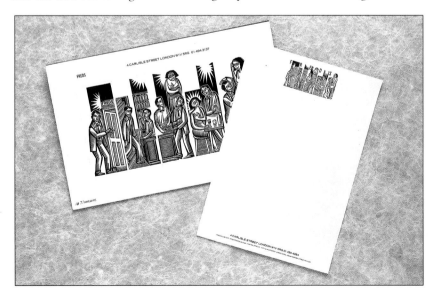

sary, even if only transparencies are available. If the subject is still living, the most recent possible photographs should be obtained. Picture researchers can also find newspapers and other documentary ephemera, and the illustrator should be told if the subject is likely to appear in any other media.

Some illustrators can find their own references. This may be because they have excellent libraries, containing a wide range of material – art books, encyclopedias, old magazines and comics, for example. It may be because they are particularly interested in a topic, or it may be because they are widely travelled and have copious sketch books and their memories to draw on. Art directors acquire this kind of knowledge about the areas that especially interest illustrators from experience and from personal contacts.

DEADLINES

When you contact an illustrator to commission a piece of work you know when you want it by. The first task is to set up a schedule between yourself and the illustrator. For a job with a two-week deadline this could follow the steps shown in the box. Generally if the deadline is about two weeks away, the art director may build in a couple of days for safety and say the job is needed in twelve days' time, not fourteen. If anything is going badly wrong, however, it should be picked up at the rough stage.

This sort of schedule is the basis for most commissions, although some will be much more elaborate and, if several people are involved in the process, may include the provision of more roughs. If the deadline is incredibly short, this schedule can be compressed into an overnight timetable, with the illustrator discussing ideas and roughs over the phone or even working beside you. Trial and error will reveal which illustrators work best under these sorts of conditions.

Above A nice mixture of well-researched images and pastiche illustrations is used in these promotional adverts for a paper manufacturer.

Right Adhesive-film labels for a furniture company, using re-drawn versions of found illustrations to give a vernacular look. A witty touch is the fact that they peel away from thin pieces of wood rather than backing paper.

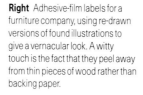

Budgets and fees

AS ART DIRECTOR one of your responsibilities will be the handling of a budget. This will sometimes mean that you have total control over the monetary side. For example, if you are designing corporate stationery that uses an illustration, you will prepare a budget for all the typesetting and artwork costs as well as for the illustration. This estimate will be presented to the client, together with the design fee, before work commences.

An art director on a large magazine will not work as closely with the financial aspect of the job. There will be an annual rolling budget, which will have to be respected. Someone from the editorial or financial side will soon intervene if the budget is consistently overstepped, but this will not affect the day-to-day commissioning because a set range of fees operates. On small publications the budget may be operated on a week-by-week basis – a low-cost week could be followed by an expensive production the next week, while overspending on one issue would mean fewer illustrations in the next.

In most fields of illustration there is little haggling over money between art director and illustrator. In advertising, especially because most illustrators work through agents, the advertising agency and agent usually have a lengthy discussion over fees, but the illustrator does not get involved.

FEES AND EXPENSES

Each area of design has its own scale of payment. Illustrators can demand a much higher price for work in advertising than they could hope to get from an editorial commission, but advertising work may take much longer.

In publishing there is generally a range of set fees, with colour work being more highly paid than black and white. Magazines differ from each other, but if, for instance, the fee for a cover is £300, that is the fee regardless of which illustrator is used. The art director may be able to use his discretion and break this rule if the deadline has been particularly tight or the circumstances especially difficult.

Expenses should cover any travel that is necessary to complete the job, although they do not include travelling to and from the art director's office; reference books, but not artists' materials; and tickets to relevant events for research purposes. All reasonable expenses should be honoured. The illustrator will usually invoice for expenses separately from the fee, and should include receipts for all items. If it is obvious at the outset that the expenses on a particular job will be high, an advance against these should be provided.

If an illustrator is sent on location, all travel arrangements should be set up and paid for by the client. The illustrator should be given an advance, with instructions to return with all receipts and either the excess money or bills to cover additional expenditure.

REJECTION FEES

Rejection is a difficult business. It is not simply a case of a bad piece of work going unpaid. If an illustrator has not achieved what you expected, you have to

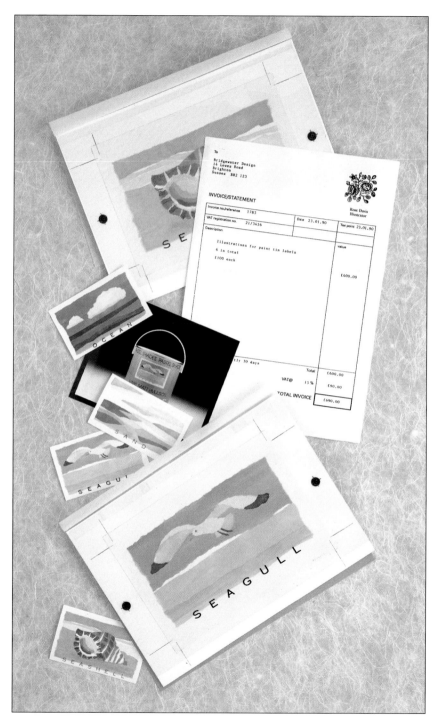

accept at least part of the responsibility for not having briefed the illustrator or supervised the work properly, and you must agree a mutually acceptable settlement. Contracts sometimes specify a cancellation or rejection fee, usually 50 per cent, but if there is nothing in writing, each case has to be treated separately. You should assess the reasons for the failure of the job and reach a figure in settlement.

If the illustrator has just started the job, the rejection fee may be less than it would be if the illustration were completed and the job falls through for reasons that are nothing to do with the illustrator. If an article is dropped from a magazine, for example, the art director has an obligation to honour the full fee.

A selection of work from a job, including the artwork and the printed results, and the illustrator's invoice for this.

Copyright and contracts

THE BERNE CONVENTION has attempted to bring countries throughout the world into line on copyrights and contracts. Despite this, the standard contract and copyright laws still vary slightly from country to country.

COPYRIGHT

In Britain, the Copyright, Designs and Patent Act, 1988 states that an illustrator owns the copyright of a commissioned illustration, and that copyright protection shall last for 50 years after his death. This provision applies only if the illustrator is freelance. If he or she is employed in-house, the employer owns the artwork and the copyright.

A freelance illustrator can assign or sell all or part of the copyright in a work to the employer. Indeed, some employers insist on this, and the art director should always inform the illustrator that this is the case before the work is commissioned.

Buying the copyright of an artwork does not, as is often commonly supposed, mean ownership. In law, ownership of the artwork and its copyright are two separate properties, and the sale of one does not imply the sale of the other. Artwork should be returned on demand if it is not returned as a matter of course when the job is completed.

Always make sure if you have bought first serial rights for the country in which you are working or if you have bought world rights. Book publishers sometimes use different covers in different territories, and it makes little sense to pay for world rights, which demand a considerably higher fee because the illustrator is giving up any opportunity of selling the work again overseas.

If, as art director, you buy more than first serial rights or if a particular job requires the illustration to be reproduced more than once over a period of time, you are entitled to have access to the artwork. In fact, as the illustrator retains the right to have the artwork back – and indeed to sell it – it is best to have a transparency made before returning the artwork. This also makes storage easier and safer.

A piece of artwork may be specifically tied to one article, and it may seem inconceivable that it could be used to illustrate another. However, an illustration commissioned by a US magazine on "The End of the American Dream" was later bought by a German magazine to run with an article on acid rain. Magazines and newspapers often have syndication departments to sell their journalists' work overseas, and the illustration can be included as part of the package if the buyer requests it. The illustrator should always be paid a residual fee for additional use, and this percentage of the original fee should be set out in the contract.

It is not only a shock for the illustrator to discover that his or her work has been re-used elsewhere with neither consent nor payment; it is also an embarrassment for the art director.

CONTRACTS

A contract can be written or verbal; a contract can even be implied. In whatever form it is couched, however, it is binding if it contains the following

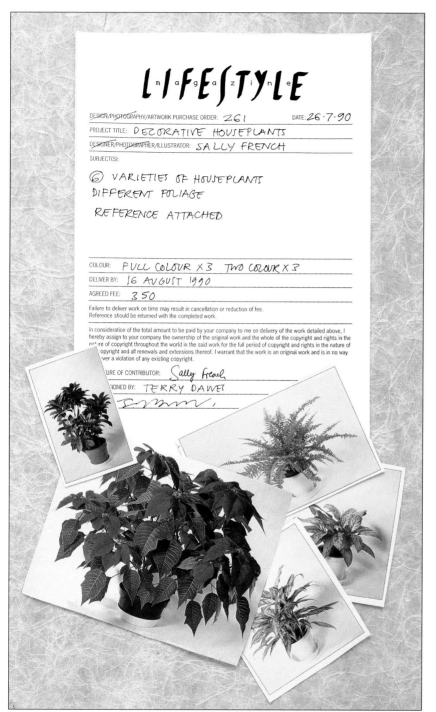

LIFESTYLE magazine

DESIGN/PHOTOGRAPHY/ARTWORK PURCHASE ORDER: 261 DATE: 26·7·90

PROJECT TITLE: DECORATIVE HOUSEPLANTS

DESIGNER/PHOTOGRAPHER/ILLUSTRATOR: SALLY FRENCH

SUBJECT(S):

⑥ VARIETIES OF HOUSEPLANTS
DIFFERENT FOLIAGE
REFERENCE ATTACHED

COLOUR: FULL COLOUR X 3 TWO COLOUR X 3

DELIVER BY: 16 AUGUST 1990

AGREED FEE: 350

Failure to deliver work on time may result in cancellation or reduction of fee.
Reference should be returned with the completed work.

In consideration of the total amount to be paid by your company to me on delivery of the work detailed above, I hereby assign to your company the ownership of the original work and the whole of the copyright and rights in the nature of copyright throughout the world in the said work for the full period of copyright and rights in the nature of copyright and all renewals and extensions thereof. I warrant that the work is an original work and is in no way ever a violation of any existing copyright.

URE OF CONTRIBUTOR: Sally French

IONED BY: TERRY DAWES

three elements: an offer, consideration (i.e., money) and acceptance. The commissioning of illustrations tends to be full of contracts whose terms are mainly verbal and implied, and the written element is minimal.

The Copyright Act says the "implied terms of the contract" are that, first, the commissioner will use the illustration for a specific purpose; second, that the illustration will not be used again without the illustrator's permission; and, finally, that the illustrator will not re-use the work to the detriment of his client.

The illustrator also has two rights, should he or she choose to assert them, the rights of paternity and of integrity. The right of paternity means that the illustrator is credited for the work; the right of integrity prevents any changes being made to the artwork, a right that is generally considered to relate most closely to the field of fine art but that has worried the advertising industry in particular. Most illustrators realize that there has to be a degree of give and take in all commissions, but it is always worth knowing the ins and outs of the contract you have asked the illustrator to sign.

Left An example of a magazine's artwork purchase order. It includes all the relevant information pertaining to an illustration job.

The job

WHETHER YOU ARE in advertising or in publishing, your role throughout the illustration process is crucial, whether it is monitoring the progress of the rough or acting as the means of communication between client and illustrator.

REASONS FOR ROUGHS

The purpose of a rough is two-fold. The first, obviously, is to check that the idea works, that the illustrator has chosen the right way to handle the subject and that the overall impact will be how you imagined it to be. The second is to get the idea seen by all the people who have to approve it.

Sometimes the art director has only him- or herself to satisfy. Many illustrations, especially those used inside magazines, are purely the responsibility of the art department. They may be shown to the editorial team, but the art department is generally deferred to in these cases.

On other occasions, however, there may be entire

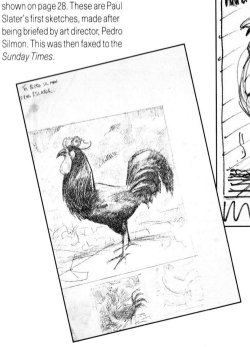

Below A rough for a cover for the *Sunday Times Magazine* on the Bicentenary of the French Revolution, the original of which is shown on page 28. These are Paul Slater's first sketches, made after being briefed by art director, Pedro Silmon. This was then faxed to the *Sunday Times*.

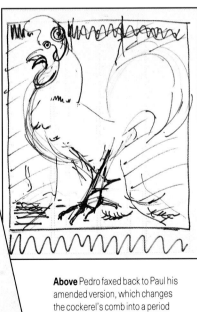

Above Pedro faxed back to Paul his amended version, which changes the cockerel's comb into a period hat and makes the backdrop a French flag, hung as if in a portrait studio.

Right The printed cover, framing the painting with a white edge.

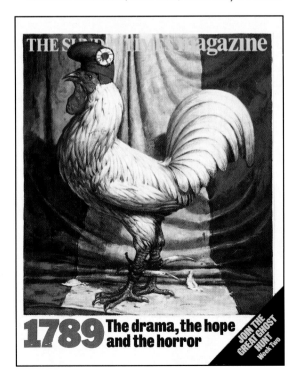

THE SUNDAY TIMES Magazine

1789 The drama, the hope and the horror

JOIN THE GREAT GHOST HUNT Week Two

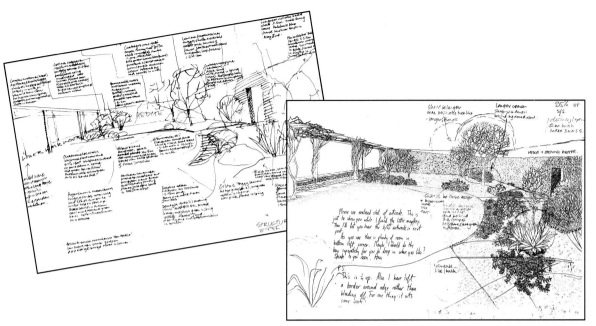

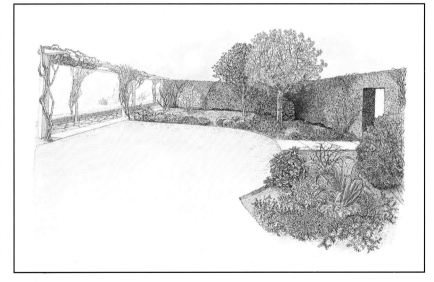

Far left This is a spread from a book on "companion planting" and is about planning a garden for the four seasons. The idea was to illustrate· as many plants as possible for each season of the year. Shown here is the process of illustrating the winter garden. First is the landscape gardener's own rough layout of the plants to be included, with extremely detailed notes about their appearance and their full Latin names. This enables the illustrator to find additional reference. The illustrator's first rough (**left**) includes her comments to the designer about cropping and so on. The landscape gardener has added her comments to this rough.
Below The finished artwork.

committees to satisfy. In an advertising agency, there is not only the account team, but also the client company, in which any number of people may have to approve the final artwork. A rough is usually as much for their benefit as for you to check the illustrator's progress. People who are unfamiliar with an illustrator's work can find the difference between a black and white sketch and a full colour, finished painting difficult to grasp, and providing a series of roughs along the way can be a great help.

ROUGH DETAILS

The detail involved in a rough will vary from job to job. For complex jobs or when an illustration will have text run around it, a fairly detailed rough will be required. If colour is vitally important to the project and plays the predominant role, it will be important that the rough is in colour.

Sometimes the rough will be worked on further and actually form the basis of the final illustration. In some instances, the rough will be no more than a thumb-nail sketch, but if you already know an illustrator's style intimately, you can visualize how that sketch will develop into the finished drawing, and that may be sufficient for your purposes.

Making changes and refinements

A ROUGH IS ALSO THE STAGE at which you can decide that something is not working and either ask the illustrator to amend it or, in the worst case, to start again.

Sometimes no more than stylistic refinements to a drawing are required, and you must decide how much you want to influence how the finished piece looks. Some illustrators may not draw hands in a way you like, although in every other area they may be very strong. It is always difficult to suggest small stylistic changes, because it seems ungenerous and can be counter-productive to hire somebody for what they do and then to nit-pick over small details. Asking an illustrator suddenly to change his or her style so that the hands are drawn to your liking can lead to an unsatisfactory end result.

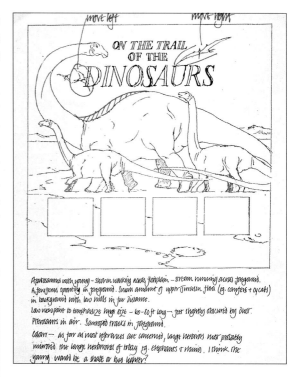

Left and above Two stages in the process of designing a book cover. The first is the art director's conception of how the cover should look; this is quite roughly traced out, with the main elements – the type, the inset boxes – in place. The illustrator has taken this a stage further, introducing more elements in the form of the family of dinosaurs and a greater sense of the landscape. Together with this are the illustrator's copious notes about colour and so forth. The red marks are the art director's suggested amendments, two about the legibility of the type, one because the back of the dinosaur appears too thin.

Right Another spread from the same book has the art director's final amendments, often small colour details, written on a tracing-paper overlay, so that there is no ambiguity in the instructions.

Left and below The final stages of the cover drawing from page 56. The final, small instructions (**left**) are to lighten parts of the background and to delineate more clearly the dinosaurs from one another. The finished artwork (**below**) is seen before the addition of the overlays for the type, the inset boxes and the instructions for the printer. It is interesting to compare the artwork with the first rough, seeing how much extra space the illustrator has allowed around the image so that it can be precisely cropped to work successfully.

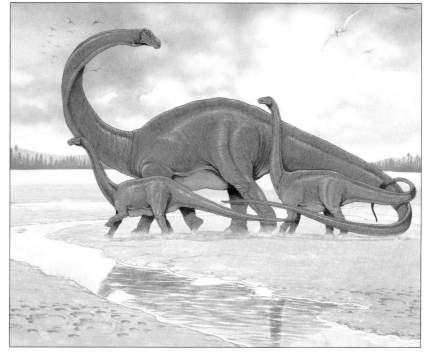

You should always make sure that the illustrator sends you a copy of the rough and keeps the original. This may seem an obvious precaution, but it can be very frustrating to try to explain a visual concept or a particular line over the phone if you have the only copy. It is usually best to see the illustrator with the rough, because you can be sure that any changes to be made will be carried through and you can also be sure that you both understand what needs to be done.

Assessing the result

WHEN THE ARTWORK ARRIVES the art director is usually the first person to see it. You have to decide if it has met your expectations and criteria; in short, if it is a success. Then comes the job of showing the artwork to everyone else involved in the project. This can be a daunting process, and other people's expectations may not coincide with yours. They may not have successfully made the imaginative leap from the rough to the finished stage, and the artwork may take them by surprise. You should not try to oversell the work, but you should present it positively. After all, you have exercised your considered judgement throughout the process, and you and your team should trust your decisions.

Of course, the job is not finished when you receive the artwork. By definition, an illustration *illustrates* something. It is not a piece of art that will be seen on a gallery wall (although it may end up on one). Primarily, however, no one outside your company or the client's company will see it as a piece of work on its own. By being placed in the context for which it was drawn, it will be immediately altered, and, one hopes, with supportive type and sensitive design, this will be for the better. Final judgement should therefore be reserved until it is seen as a part of the whole layout.

The final stage is the printing, in whatever form, and this is when you should try to look at the finished product with an outsider's eye. You can now assess the success of the work in terms of the

Right The last colour and picture corrections before the final printing was done.

Far right The finished artwork and a copy of the book, the culmination of the project detailed on pages 56–7.

Below The printed version of an advertisement for 3i art-directed by Mark Reddy. This was one of a series in which the illustration and typography worked together in the bold way shown here.

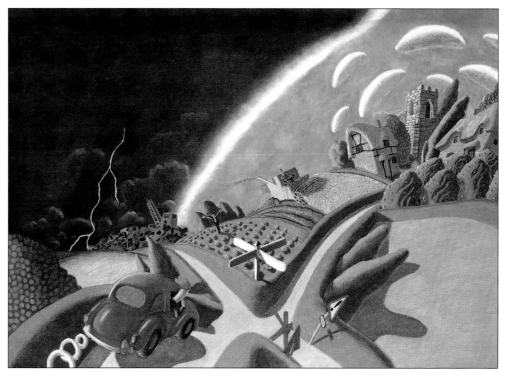

Above Illustrator Richard Adams's finished artwork for the 3i advertisement. Notice that he has done the illustration as a squared-up picture – the step effect and overlaid block of text have been done at the separation stage. The colour printing is of very high quality, and when the advertisement appeared in newspapers, on the very cheap newsprint, the effect was surprisingly good.

market place. Does the illustration work as you turn the page? Does it stand out among ten others on a billboard site? Does it give a fresh identity to that familiar product? These questions can be asked only at the end of a project, and the answers should tell you if your instincts and decisions were right.

RIGHT OR WRONG?

Mistakes happen, and it is all too easy to criticize the work of others without fully knowing the circumstances. The pressures of deadlines and of clients who "know best" can take their toll and lead to disappointing results. The wrong illustrator may have been commissioned, or the right illustrator may not have come up to scratch. Sadly, these eventualities are not always apparent until you see the finished job and have the necessary distance from it to appreciate the fact. One hopes that this situation won't arise too often, but it is always possible to learn from disappointments.

An art director should be able to spot a good illustration even if it is surrounded by a bad piece of design, or to see the inherent quality of an illustration that has been let down by mediocre printing. Remember, too, that a carefully thought out and composed drawing will have a sense of balance that can be all too easily sabotaged by inconsiderate typography.

SECTION THREE

USES OF
ILLUSTRATION

EDITORIAL ILLUSTRATION

EDITORIAL ILLUSTRATION is commissioned to accompany feature articles, to comment on news events or to evoke the contents of a book. Such illustration is generally distinct from advertising illustration in that the image is not there to sell or promote a product but to reinforce and enhance the written words that it accompanies. There are, of course, areas where this distinction blurs – mass-market paperback covers, for instance – but in general, editorial illustration tends to be concerned with ideas and with serving or communicating concepts to the reader. It is a field that has produced some of the most innovative and experimental illustration work.

Right and below An interesting use of illustration, which works against preconceived notions of the sort of image that *Marxism Today* would have on its cover. The warm colours and positive image used by Ed Briant signal strongly the new look that the magazine had recently been given.

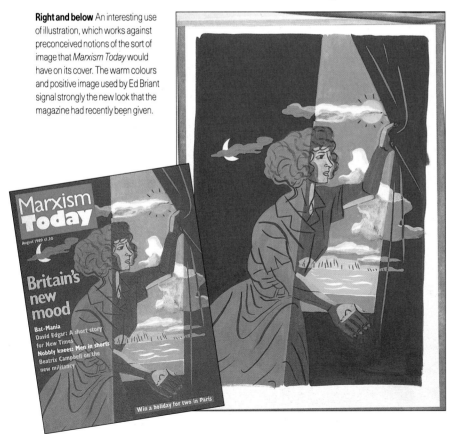

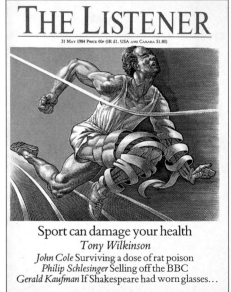

Sport can damage your health
Tony Wilkinson
John Cole Surviving a dose of rat poison
Philip Schlesinger Selling off the BBC
Gerald Kaufman If Shakespeare had worn glasses...

Above A striking scraperboard illustration by Bill Sanderson. If it had been done for the inside of the magazine it would probably have been less extreme, but the use of distortion works well for a cover image. It arrests the eye and is rather shocking.

Below The illustration for a newspaper article on the world's weather was done almost overnight. The size of newpapers permits the use of strong graphics that can communicate a lot of information directly. It's interesting to compare the original with the printed version; newspaper colour printing and the quality of paper are still quite rough.

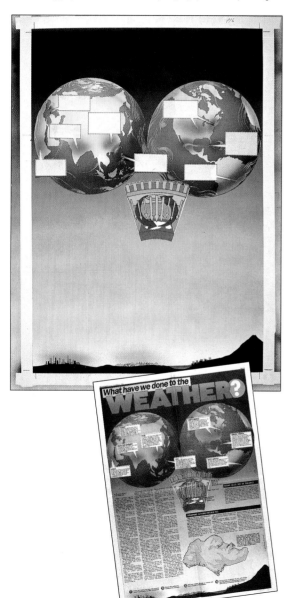

Above The title for this enigmatically illustrated book is on the back: the "Originals" tag is the only text on the front. This was part of an interesting attempt (since abandoned) to sell books by imprint and image only.

Left and below Sometimes it is a shame that book covers aren't larger – the detail and tone of Geoff Grandfield's pastel drawing are so rich that they deserve more space. Fiction offers possibilities for complex, clever images, as illustrators are inspired by writers.

Magazines

MAGAZINES ARE AMONG THE MAJOR EMPLOYERS of illustrators, and the work they commission tends to define the contemporary state of illustration. This is partly because of the quantity of work produced and the fact that it is current (often done within the month before publication), and partly because it covers such a wide variety of subjects.

Magazine briefs range from commissions to paint the portrait of a well-known novelist, to illustrating how the economy of a country has been crippled by the importation of too many goods, to decorating three different fish recipes.

The deadlines for magazine work are tight – it is considered a luxury to have more than two weeks to do a job. A complicated table of informational graphics may have a longer deadline, but usually even complex jobs have to be done quickly. Magazine production schedules vary enormously. A weekly listings magazine turns work round very quickly – an illustration commissioned on a Monday can be at the printers on Tuesday and on the bookstand on Thursday. A glossy monthly magazine will probably have a more leisurely turnaround. But in both cases it is enormously exciting for illustrators and for art directors to see their work put so quickly before the public.

Magazines have traditionally been a forum for illustrators. As the work is seen soon after its conception, illustrators are able to keep abreast of their peers, to see what type of work is being used and to be inspired by the best of it. Magazines also enable art directors to talent-spot. A magazine such as the *Radio Times* in the UK used to be an illustrator's showcase, and it was every illustrator's dream to have work appear in it. Although this is no longer true of any one magazine, the scope for illustrators is broader than ever. There are now more publications and more subjects, and the examples shown here only scratch the surface of the range of topics illustrated.

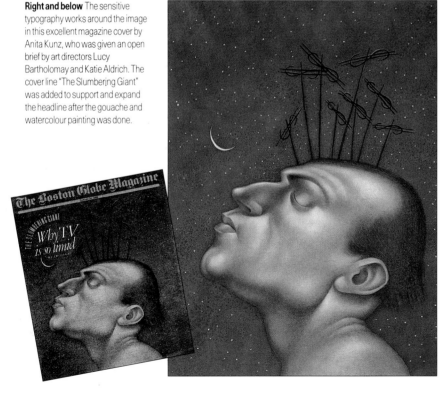

Right and below The sensitive typography works around the image in this excellent magazine cover by Anita Kunz, who was given an open brief by art directors Lucy Bartholomay and Katie Aldrich. The cover line "The Slumbering Giant" was added to support and expand the headline after the gouache and watercolour painting was done.

Right Mirco Illic's technique is ideally suited to the subject here. His almost etched style is used to impersonate the portrait of Washington on the dollar bill, and the simple but effective concept tells you at a glance exactly what the article is about. The use of limited colours also heightens the effect of the cover.

Below For evoking land- and city-scapes illustration is a remarkable tool. Why then do so few magazines use it? Here Paul Cox's watercolour of Milan is given almost an entire spread, and is a great introduction to a feature that encompasses details of everyday life as well as of architecture.

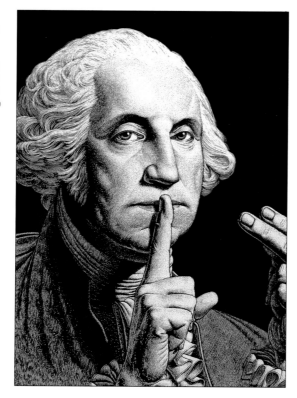

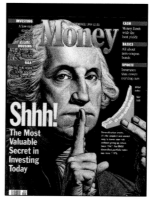

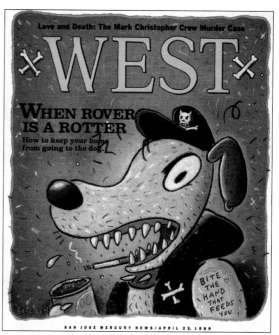

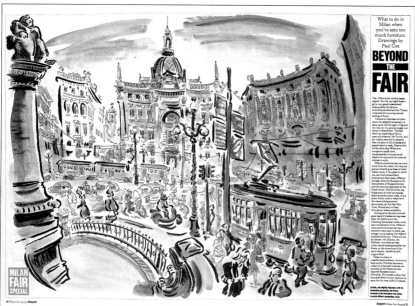

Above An amusing and appropriate magazine cover that must have been really striking on the bookstands. A strong idea, vibrantly handled by Gary Baseman.

CASE STUDY

Magazine illustration

Magazines and newspapers are really the only outlets for what I would call true caricatures – those that are not necessarily flattering to the subject. In a way, Philip Burke's paintings are a cross between caricature and portraiture. Fred Woodward, art director of *Rolling Stone* magazine, had seen Philip Burke's portfolio a couple of times over the years but did not get in touch with him until the chance to do a regular painting for the magazine's contents page arose. The magazine is renowned for its bold use of photography, and illustration has always provided both contrast and an opportunity to approach subjects in a different way. The use of Burke's illustrations on the contents page is especially striking, as it is usually the only image alongside the text.

This page "There's little art direction involved from week to week as the illustration fits into a fairly standard shape and size on the page. The Art Department tells me who the subject is and supplies reference. This is usually in the form of slides, but as many of the subjects are musicians, it will often supply video tapes for me to use. I tend to watch the videos and use the pause switch a great deal. My first sketches are really just to get to know their faces, so that I understand the features. At this stage, I tend to work quite slavishly."

66

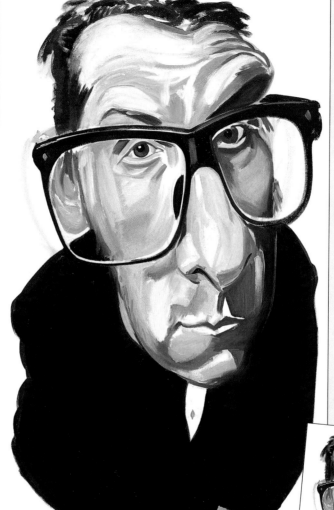

Above and right "When I feel comfortable with their features, I use this knowledge to 'recreate' my image of them. I work very large. This portrait of Elvis Costello is 6 foot by 3 foot in size and is done in oil paint on canvas. It is then photographed on to 5 inch by 4 inch transparency and it is this film that is sent to *Rolling Stone*."

Below "This commission was ideal as far as I was concerned. It started from the first issue of 1989. I had seen Fred Woodward's work in various magazines and really hoped one day to work with him. He had seen my portfolio a couple of times, and then the opportunity to do a series of portraits for the contents page came up and he asked me to do them."

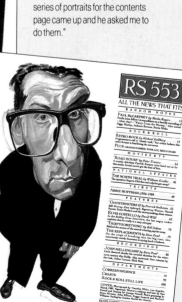

Newspapers

NEWSPAPER ILLUSTRATION HAS a distinguished history, especially the area of the editorial cartoon, which has produced names like Low and Vicky and, more recently, Scarfe, Oliphant, Gibbard and Garland.

Cartoonists and comment illustrators for newspapers and some magazines either work at the newspaper office or send batches of topical cartoons into the art director or editor. The best examples are kept on file and used as needed, while the rejects are returned to the illustrator.

Working in-house has obvious advantages. Cartoonists can react instantly to subjects or discuss ideas with the art director and editorial team. There is also the advantage of being able to make amendments or improvements there and then.

The ideas for political cartoons are always created by the cartoonist, with input from the editor and his assistants. The art director may not be involved in this process at all. Cartoonists have to produce drawings either on the spot or overnight, and this pressure requires a keen mind and a sharp eye.

For more general or "op-ed" illustrations (that is, those on the page opposite the editorial), the art director's responsibility is to discover illustrators who can cope with the extremely demanding schedules. Editorial illustrators are often on full-time contracts.

Below An extremely striking drawing by David Suter for the Op Ed page of a newspaper. It shows the kind of juxtapositions and imagery that work well for illustrations running with commentary or editorial pieces of writing.

Below A more cartoon-like approach to illustrating an article on go-getting students is used here by Steve Way. This piece is lighter in tone than the one illustrated by David Suter, so this approach suits the subject well.

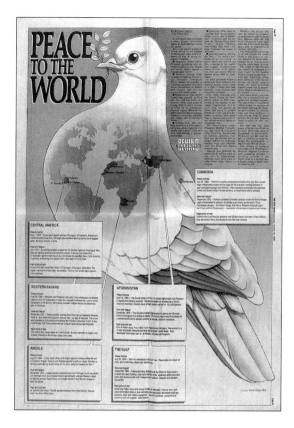

Weekend or leisure sections of newspapers have less frenetic production schedules. Subjects such as food and travel are staple topics, and these sections tend to use quite decorative illustrations. Commissioning these is more akin to magazine illustration, and the art director has to put together an adequate file of illustrators suitable for this type of work.

Cartoon strips are another regular feature of newspapers. The nationally famous strips, like Doonsbury, Peanuts and Bloom County, tend to be bought in by the newspaper from feature syndicates, but more and more frequently, art directors and editors are finding and developing new talent in this area. Steve Bell's "If", Matt Groening's "Love is Hell" and Charles Peattie's "Alex" are fine examples of contemporary cartoon strips.

Books

MUCH EXCELLENT ILLUSTRATION is to be seen on the jackets and covers of books, and publishing is an exciting and challenging arena for an illustrator to enter. He or she has to compose an illustration that not only is consistent with, and evocative of, the book's theme, but also integrates with the all-important text that gives the title and author. Indeed, some sales directors in book publishing believe that the title and author's name are much more important than any imagery that features on the book cover. As long as the image is technically well done, they are happy.

Left A typical mass-market paperback for which the gold foil-blocked lettering of the title is more important than the bland illustration. A sales director's dream?

Right The strong house-style of Faber & Faber's poetry series is the antithesis of the mass-market paperback. Serious and formal looking, it has series continuity, yet allows the illustration to be the focus of the cover.

THE DESIGN CONCEPT

To be well equipped to commission illustrations for book jackets and covers, you do need to read the text as thoroughly as possible. This may seem obvious, but the only way to do justice to an author's work is to appreciate what he or she is trying to say and to translate it visually.

Some art directors believe that involving the writer in the whole process of the jacket design is the only way to get a result that is true to both the author's view and the demands of the commercial book trade. Authors are usually open to suggestions and concepts as long as they are well explained and rationally arrived at, and the image of the interfering author with rather grim notions of the jacket image is not accurate. An art director can also help to explain to the author the thinking behind certain commercial decisions.

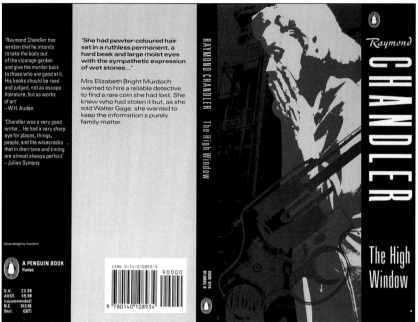

Cover design by Accident

'Raymond Chandler has written that he intends to take the body out of the vicarage garden and give the murder back to those who are good at it. His books should be read and judged, not as escape literature, but as works of art'
– W.H. Auden

'Chandler was a very good writer... He had a very sharp eye for places, things, people, and the wisecracks that in their tone and timing are almost always perfect'
– Julian Symons

'She had pewter-coloured hair set in a ruthless permanent, a hard beak and large moist eyes with the sympathetic expression of wet stones...'

Mrs Elizabeth Bright Murdoch wanted to hire a reliable detective to find a rare coin she had lost. She knew who had stolen it but, as she told Walter Gage, she wanted to keep the information a purely family matter.

A PENGUIN BOOK
Fiction

U.K. £3.99
AUST. $9.99
(recommended)
N.Z. $12.95
(Incl. GST)

ISBN 0-14-010893-9

Raymond CHANDLER
The High Window

Left A graphic, screen print effect using images culled from period sources works well for this Raymond Chandler book cover, one of a series with jackets handled in a similar way. The illustration is an integral part of the overall design concept.

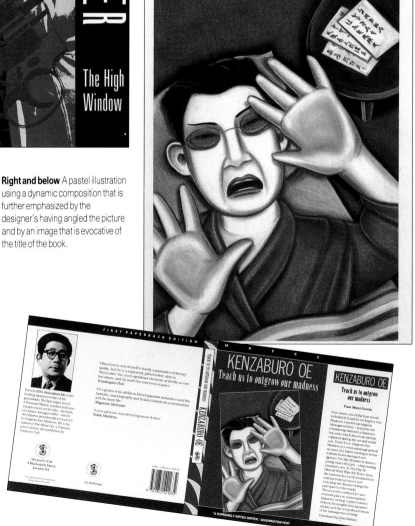

Right and below A pastel illustration using a dynamic composition that is further emphasized by the designer's having angled the picture and by an image that is evocative of the title of the book.

PRESENTING THE VISUAL

Problems can arise when you have to show roughs and ideas for book jackets in a large meeting. The managing director, the marketing and sales directors, the production chief and the editorial staff are usually present, and decisions made in this environment are rarely reached logically. Often a group consensus emerges that is not a fully thought-out critical response.

People in large meetings tend to hedge around what they really think, or they are forced to make snap judgements. Ideas are often eroded in a piecemeal way: one person may not like a small element of the idea; someone else may not like the colour green; someone else may have a slightly different view of the book. In the end you get a team decision that has been made by a group of people who are not, in the real sense, a team.

One way round this situation is to work out the ideas in smaller groups. Perhaps you should first

discuss the project with the editor and author so that you know that your ideas are solidly rooted with the people closest to the book. Then you could present this idea or ideas to the managing director, then to the sales director and so forth. People's reactions are very much more their own outside large formal meetings.

FINDING THE RIGHT ILLUSTRATOR

Art directors working in publishing need to know an extremely wide range of illustrators. At the same time as having to try to create a house-style, the art director will have to deal with a variety of books that have completely different contents: a large "how to" manual will require a different approach from a book on the environment. Unlike magazines, there can be little cross-over work. Illustrators who do a lot of work on romantic fiction are not the ones to turn to for spy stories or biographies.

BRIEFING ILLUSTRATORS

Book jackets tend to have lengthy periods of gestation; they may be commissioned as much as a year before publication.

Sometimes only a synopsis or first draft will be available from which the illustrator must be briefed.

If the jacket is heavily art directed, the illustrator may need only to read the manuscript to get details right – colour of hair, make of car, time of year – and a synopsis may suffice if the art director has a strong idea for the cover.

Sometimes the illustrator will work from a finished manuscript. This happens when a book is already published in hardback, and a new paperback

Above A menacing and disorientating image, made up of found and manipulated pictures. A controversial, brave attempt to break away from the confines of traditional book cover design.
Above left Decorative illustration can be used not only to get away from a photographic presentation of food but also to signal a particular approach to the subject.

Right When the title of a book is as obscure as this one, the function of illustration is to be faithful to the ideas of the book and to try to illuminate it. The image that Ian Miller came up with is arresting, intriguing and menacing. This effect is heightened by the quiet typography and the off-centre placing of the image.

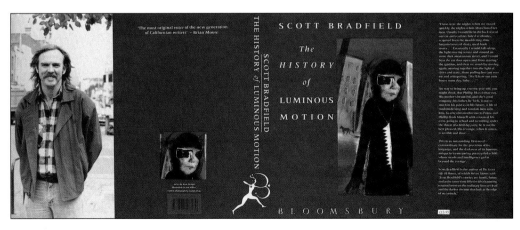

Right Another example of illustration and typography together for a "series" look, but here the typography is dominant, while the illustration provides the key image from the stories.

Below and left Setting a style for a series can be done through typography or illustration or, most strongly, both. For this series of crime novels, the first death in each story is seen from above, and this not only tells you instantly what the book is about but immediately evokes the setting.

I like sunshine all day.
...s round to play.

I like tumbling in hay.
Do you?

MY BEAR

I LIKE ... DO YOU?
by Ruth Thomson and Ian Beck

lishers. Contact with the author is also possible, although generally the art director acts as a go-between.

CHILDREN'S BOOKS

The art director's role in children's publications (apart from reference books) is quite different from that necessary for adult literature. Editors of children's books tend to commission illustrators themselves, either to write and draw their own books, or to work with an author. The designer's job is to specify a sympathetic typeface and to position the text on the pages.

However, it often happens that illustrators whose work is extremely strong narratively find it difficult to produce an equally strong cover image. It is a very different discipline and requires a change of approach. Unfortunately, even very good children's picture books often have indifferent covers as the

On Christmas morning my little sister Sarah and I opened our presents. When it looked as if everything had been unwrapped, Sarah found one last small box behind the tree. It had my name on it. Inside was the silver bell! There was a note: "Found this on the seat of my sleigh. Mend that hole in your pocket." Signed, "Mr C."

I shook the bell. It made the most beautiful sound my sister and I had ever heard.

But my mother said, "Oh, that's too bad."

"Yes," said my father, "it's broken."

When I'd shaken the bell, my parents had not heard a sound.

cover is required. If a book has been successful in hardback, the same design is generally used for the paperback version, as the recognition factor is important.

If the illustrator is expected to come up with the idea for the jacket or to choose the section to illustrate, then it is obviously vital that he or she reads the entire manuscript. This sort of situation is more usual with the smaller, more "arty" pub-

scope for art direction is so limited.

Most of the points made above for general illustration are relevant to children's books, but an additional and vital factor is that the illustrators should pitch their work to exactly the right level and draw or paint in a way that children will respond to.

If you are art directing children's books, you must remember that they are regularly translated into many different languages, and some are pre-sold in a foreign edition even before the original work is started. Any lettering should be done as an overlay so that it may be easily replaced when the text is translated and printed elsewhere. It is also worth bearing in mind that drawings that need to be re-used in overseas editions should take a deliberately vague approach to specific details of day-to-day life to ensure that their appeal is international.

Right Cartoons are often used in books for parents about children, often because they suit the humorous way in which the text approaches the subject. Michael Heath's slightly manic and distressed style is perfect here.

Book jacket

IT'S A TRADITION with David Lodge's paperbacks that the titles are illustrated in this way. Ian Beck has done all the Lodge titles for Penguin, starting with *Small World,* which was art directed by Steve Kent. He suggested to Ian that, as one of the characters in the book was studying medieval romantic manu-scripts, it would be a good idea to have the title "lettered" and with little figures, rather like illumi-nation, attached to the lettering. That first cover worked and was liked, then the other covers were done in a similar way. So, although the subjects differed widely, they had an author identity estab-lished. Luckily, the idea works for all of them. In the case of *Nice Work,* which was art directed by Eddie Edwards, Ian was left to read the book and to make the lettering work, knowing that his illustration "carries" the whole cover.

Above Ian Beck: "I read the book and found the major theme – the clash of academe and industry. I then tried to make letter shapes out of the images of factory chimneys and academic symbols, such as classical columns and books."

Right More preparatory sketches, which introduce the main characters. They are small and peripheral on the cover, but the publishers wanted them included. A more finished rough of the entire cover design (**far right**) was prepared. Ian Beck: "In the story the female character actually wears trousers, but because the figure was so small and she's got short hair it was decided to give her a skirt – that was David Lodge's idea, not mine. At that size she could have been mistaken for a man."

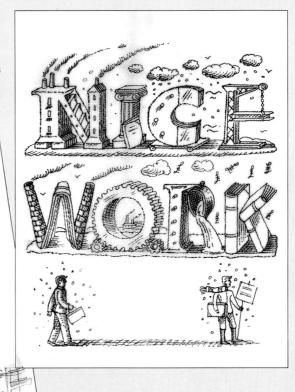

Above *Small World* was the first in this series of David Lodge book covers. Eddie Edwards, art director of Penguin: "As this was an established style, I was happy to leave it to Ian to provide his input and to get the facts right." The aim of the cover of *Small World* was to illustrate both the English academic and the American academic travelling in some way.

Below The final cover for *Nice Work*.

Book jacket

LYNN TRICKETT: "WHEN we first talked to Liz Calder [director of Bloomsbury Publishing], we showed her the calendar that we do every year to see which types of illustration she liked. We sensed that Bloomsbury was not like some other publishers we'd worked with. Sometimes you think you're going to be able to do nice things and they change everything so they turn out to be dreadful and marketing-led.

"It was on that basis that we decided to work with them, because there's absolutely no money in it. You have to do it for the end result. Bloomsbury listens to its authors; its attitude is that an author shouldn't have to live with a book in a cover he or she hates.

"We showed Miles Aldridge's work to Liz and she liked it. We all agreed that *On Double Tracks* should have an integrated cover on which the type is very much part of the design, so we wanted Miles to hand write the names and titles. It's quite a complicated book about a law case concerning the Indians' belief that they have rights to lands that somebody else is disputing. It was the Indian parts that had the most beautiful, evocative language. The barrister is driving along, a swan swoops down in front of her car, and she injures it. She and the Indians save the swan, and I asked Miles to integrate this incident into a dream map, which is how the Indians measure their land.

"Miles did a rough, which we doctored and stretched on a colour photostat machine, but it wasn't working terribly well because it was too

Right The original rough and a sketch book page showing the development of ideas. The first rough, based on maps, is already quite a finished piece of work. There are railway lines and rivers bisecting borders and a dotted rule signifying legally drawn boundaries. The figure of a magistrate was included as the book revolves around a court case, but it was not liked by anyone. The rough conveys all the atmosphere that is apparent on the finished book jacket.

Above Design group Trickett & Webb's re-arrangement, via the colour photostat machine, of Miles's rough. This was an attempt to simplify the cover image.

On Double Tracks

On Double Tracks

On Double Tracks

On Double Tracks

Left Lynn Trickett: "We always knew the type should be hand-written. Miles wrote out the title and author's name again and again, and we just chose the ones we liked best." Miles used an eyeliner pencil: "Nice to draw with as it's so oily."

Above A sheet of black-on-white images drawn for the flap. Trickett & Webb photostated them on to adhesive film and cut and pasted them on to the final artwork.

Left A detail of a colour photostat of the final artwork.

Below The final cover with the author's photograph on the flap. The blurb is printed out of a panel that was artworked by Trickett & Webb to fit in stylistically with Miles's drawing. The Bloomsbury logo is a standard item on every book and can be hand-drawn, but Trickett & Webb preferred to leave it as it was.

complicated, although there were obviously beautiful elements in the painting. Brian [Webb, Lynn's partner] thought that we should concentrate on the swan. Miles and I were quite sorry to do this, although it was obviously a good idea to feature that element so strongly. What we decided to do was simplify the image but keep the elements that gave it the quality of a land map."

INFORMATION ILLUSTRATION

INFORMATION ILLUSTRATION is a term that immediately brings to mind statistics, direction signs, pie charts and diagrams, but in fact, information illustration covers a diversity of styles and demands a wide range of talents. It is an area in which you can see statistics supported or explained by cartoon-like symbols or a subject treated with an almost classical approach using an extraordinary level of draughtsmanship.

Illustration is a great instructional medium – information is taken in more easily when it is conveyed visually. Although it can be presented in lengthy text, even combined with relevant photographs (often an art director's fallback), the only way to make information exciting is the creative use of illustration.

Pure information illustration is essentially graphics-based, and here the use of type and symbols and the ability to organize and convey data are as important as the ability to draw. Information illustration, however, encompasses many other subjects. Technical drawing, for example, includes representations of objects such as ships, buildings and cars, while botanical and natural history illustration covers detailed renderings of plant and animal life.

Illustration works on many levels: it can be a practical tool enabling a ship to be built or it may be

Right A brochure for the Department of Trade and Industry about the single European market planned for 1992. As this is an information booklet, the illustrations and text have been laid out in an economical and attractive way, making good use of a limited palette of colours.

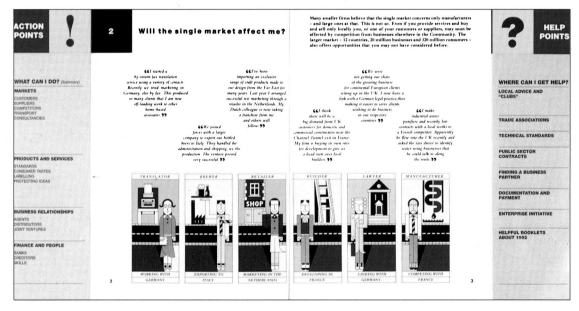

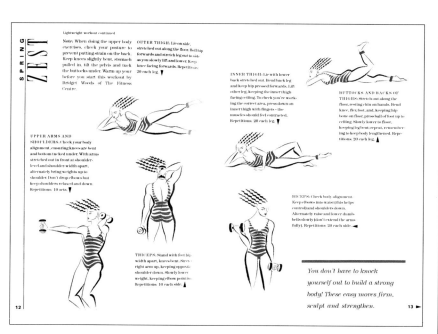

Left Fashionable, stylish illustrations were used in an area where rather drab drawings are customary. A second colour was put to good effect to lift the spread.

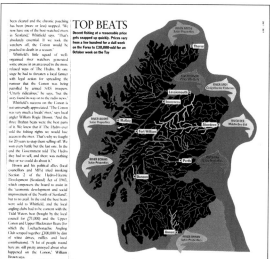

Left A medical illustration of a view through the top of a human skull to show areas of the brain. In cases such as this the artist may have to construct a life-like representation from disparate sources such as X-rays and autopsy photographs.

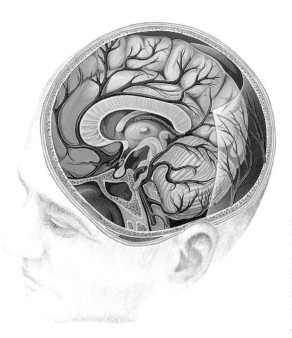

simply a guide through the steps of tying a reef knot. It can also be the only way in which certain subjects can be visualized or explained. The human body, for instance, can be shown in X-rays or photographed in part, but only illustration can show, in an almost three-dimensional way, how muscles overlap organs and how blood is routed.

In this field, illustrators have to be both designer and artist. It is unfortunate that the skills are almost always separated both in colleges and at work.

Above An illustration of coveted fishing rivers in Scotland was given a very graphic look by Line and Line. Colour is used to key in the rivers to their names and related information.

Commissioning information illustration

AN ART DIRECTOR COMMISSIONING in this area is looking for the ability to convey or show something specific. These types of illustration are time-consuming to produce and mistakes are costly, and you have to know that the illustrator is *technically* capable of carrying out the brief.

Time is the most important element in commissioning information illustration. When the job is complex, an illustrator is faced with a huge amount of information, and he or she not only has to find a way to make the data readable but also to make them work visually in an appropriate style.

There is also the matter of typesetting. The art director will usually specify the typeface so that it is sympathetic with the type used in the rest of the project, but the illustrator will generally want to order the setting from a typesetter he or she has used before.

If the art department adds the type to the illustration, the illustrator will have to calculate how much space to leave, and problems can occur with the fit. Modern photosetting makes it difficult to estimate exactly the final size and length of the type, and if mistakes happen, you will have to go back to the illustrator.

A more satisfactory solution is to order the typesetting yourself and provide the illustrator with it. If the illustration is for a publication such as an annual report, where it is important that the type matches, it is better if the art department supplies it and the illustrator applies it. Artworking type overlays is extremely time-consuming, and it also involves careful proofreading, which is essential with any job that involves a great degree of type. All text in a project has to be proofread, and text that appears on illustrations is no different. It may seem a harsh judgement, but proofreading is a job best not left to illustrators – they are notoriously bad at spelling!

THE BRIEF

When discussing a brief with an illustrator, it is vital that the art director gives such information as the ultimate size and the number of colours (one, two, three or full four colour) that are available, but the illustrator should be left to come up with an idea to portray the necessary information. It is almost impossible for an art director to impose a way of working on an informational illustrator, although certain jobs will require quite specific imagery. It is necessary, however, to be strict on technical specifications so that the finished illustration fits in with the house-style of the project.

THE BUDGET

Ask the illustrator to quote a price before work begins. It is difficult to offer an informational illustrator a set fee on a large job because of the typesetting, administrative and technical costs involved. The complexity of the job always has to be considered when discussing money with the illustrator, and although it can be given a more or less complex treatment according to the budget, at the end of the day you have to include *all* the information – that is the one definite quantity.

WHEN YOU TALK TO AN ILLUSTRATOR always be sure of the technical terms you are using. Do you both mean the same thing when you talk about separated artwork, for instance?

Some illustrators prefer the printer to do the colour separation while they supply black and white artwork. This is partly because a printer, working on film and able to cut and paint-out, can be more precise. Cameras and processing equipment allow printers to make more accurate film overlays, and, as their involvement is further along the line in the production process, elements that rely on a mechanical act are often better done at this stage.

An illustrator generally does the separations manually on overlay material such as Kodatrace. There is only a certain degree of accuracy you can achieve by hand, so in terms of registration this task is often best left to the printer.

Depending on your contract, it can also be financially advantageous for the printer to separate the colours. It is quicker, and therefore cheaper, for the illustrator to do black and white work and to specify the colours. The printer's costs could be higher, but colour separators often work to a page rate for a project, and this keeps the price down.

Full-colour artwork is scanned like any other illustration, although there is usually a black line overlay for the text. Such artwork can either be done as painted flat gouache or it can be airbrushed. Airbrushing is a time-consuming process, and it can

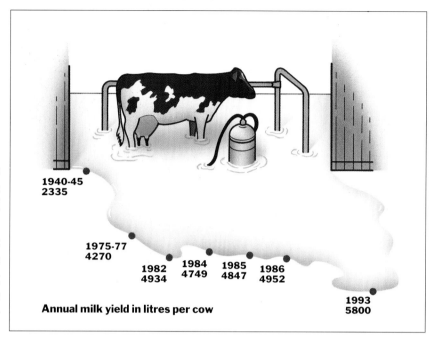

Annual milk yield in litres per cow

1940-45
2335

1975-77
4270

1982
4934

1984
4749

1985
4847

1986
4952

1993
5800

be difficult to ensure that the quality of the colours is exactly right because the other colours are masked off while one specific area is completed. This makes it impossible to check that the colours work as planned until a section is finished. It may be best to get the printer to lay flat colours, although this means that you have to imagine what the end product will look like.

Mistakes with colour – choosing a blue that the client dislikes, for instance – are a real problem with full-colour artwork. Alterations can be costly and time-consuming, as the work will have to be re-done by the illustrator, sometimes even from scratch. Colour-specified work, therefore, has the great advantage that the colour can be changed just before it goes to the printer or even at the first proof stage. If the art director suddenly wants red instead of blue when he or she sees the artwork or proof, this presents no real problem with specified colour.

Above An information illustration from the *Sunday Times Magazine* accompanying an article on rural Britain in crisis. It illustrates the EEC milk quotas and surpluses in a witty way and at the same time gives the information clearly.

Technical illustration

TECHNICAL ILLUSTRATION IS THE METHOD of showing information of a three-dimensional nature in, most often, a flat, two-dimensional medium. Such illustrations are used to complement text in a literal, yet illuminating way, and illustrators have to know how to balance the amount of detail and information with legibility and usefulness. Converting what is often rather basic reference material into a correctly projected drawing requires enormous expertise. It is not a "dry" skill, all draughtsmanship and detail; in the hands of its best practitioners, it is both evocative and exciting.

When you use technical and explanatory illustration, it is important that you know your illustrator's style and method of working. In these fields there is not much scope for interpretation; you choose illustrators for their ability with their craft, the clarity with which they draw. The provision of roughs to test style are not particularly relevant if you know the illustrator is going to approach the project with his or her customary skill, but roughs to see how the information is being interpreted are of course vital.

Below Illustration is used in this book on house design as an adjunct to photography. It is drawn to show as clearly as possible how things look and how they are constructed.

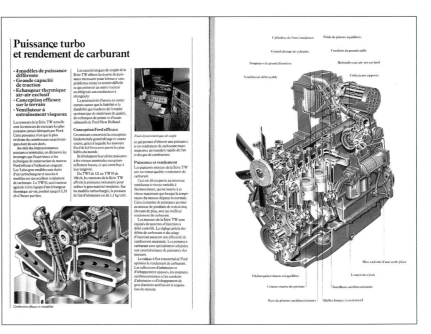

Right Cutaways in a motor vehicle brochure have a purely technical function. This type of work is highly specialized and requires a deep understanding of the subject.

Right Black and white pencil drawings are used for a spread on photographic equipment. Small illustrations for technical books are more commonly done with a technical pen, but the detail and shading holds surprisingly well here, even with a 66 per cent reduction.

Left A spread from the Condé Nast *Traveler* magazine showing the major buildings on New York's Fifth Avenue. It is beautifully drawn by John Grimwade: the details such as the shadows cast by the buildings are well observed, and the type fits extremely well into the spaces left for it. The overall effect is very strong.

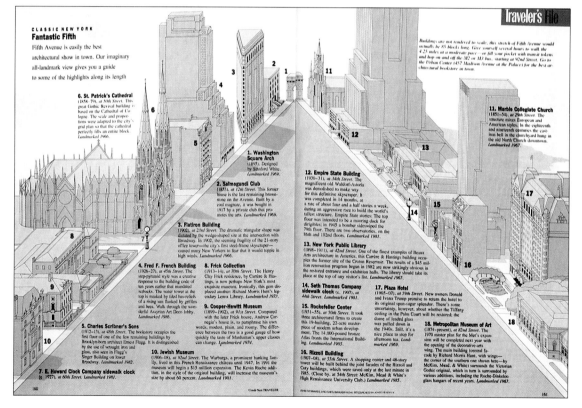

CLASSIC NEW YORK
Fantastic Fifth

Fifth Avenue is easily the best architectural show in town. Our imaginary all-landmark view gives you a guide to some of the highlights along its length

6. St. Patrick's Cathedral
(1858–79), *at 50th Street*. This great Gothic Revival building is based on the Cathedral of Cologne. The scale and proportions were adapted to the city's grid plan so that the cathedral perfectly fills an entire block. *Landmarked 1966.*

1. Washington Square Arch
(1895). Designed by Stanford White. *Landmarked 1969.*

2. Salmagundi Club
(1853), *at 12th Street*. This former house is the last remaining brownstone on the Avenue. Built by a coal magnate, it was bought in 1917 by a private club that promotes the arts. *Landmarked 1969.*

3. Flatiron Building
(1902), *at 23rd Street*. The dramatic triangular shape was dictated by the wedge-shaped site at the intersection with Broadway. In 1902, the seeming fragility of the 21-story office tower—the city's first steel-frame skyscraper—caused many New Yorkers to fear that it would topple in high winds. *Landmarked 1966.*

4. Fred F. French Building
(1926–27), *at 45th Street*. The step-pyramid style was a creative response to the building code of ten years earlier that mandated setbacks. The water tower at the top is masked by tiled bas-reliefs of a rising sun flanked by griffins and bees. Walk through the wonderful Assyrian Art Deco lobby. *Landmarked 1986.*

5. Charles Scribner's Sons
(1912–13), *at 48th Street*. The bookstore occupies the first floor of one of the few remaining buildings by Brooklyn-born architect Ernest Flagg. It is distinguished by the use of wrought iron and glass, also seen in Flagg's Singer Building on lower Broadway. *Landmarked 1982.*

7. E. Howard Clock Company sidewalk clock
(c. 1927), *at 50th Street*. *Landmarked 1981.*

8. Frick Collection
(1913–14), *at 70th Street*. The Henry Clay Frick residence, by Carrère & Hastings, is now perhaps New York's most exquisite museum. Ironically, this gem displaced another: Richard Morris Hunt's legendary Lenox Library. *Landmarked 1973.*

9. Cooper-Hewitt Museum
(1899–1902), *at 91st Street*. Compared with the later Frick house, Andrew Carnegie's house is, to paraphrase his own words, modest, plain, and roomy. The difference between the two is a good gauge of how quickly the taste of Manhattan's upper classes can change. *Landmarked 1974.*

10. Jewish Museum
(1906–08), *at 92nd Street*. The Warburgs, a prominent banking family, lived in this French Renaissance château until 1947. In 1991 the museum will begin a $15 million expansion. The Kevin Roche addition, in the style of the original building, will increase the museum's size by about 60 percent. *Landmarked 1981.*

Traveler's File

Buildings are not rendered to scale; this stretch of Fifth Avenue would actually be 85 blocks long. Give yourself several hours to walk the 4.25 miles at a moderate pace—or fill your pocket with transit tokens and hop on and off the M2 or M3 bus, starting at 92nd Street. Go to the Urban Center (457 Madison Avenue at the Palace) for the best architectural bookstore in town.

11. Marble Collegiate Church
(1851–54), *at 29th Street*. The structure mixes European and American styles. In the eighteenth and nineteenth centuries the cast-iron bell in the churchyard hung in the old North Church downtown. *Landmarked 1967.*

12. Empire State Building
(1930–31), *at 34th Street*. The magnificent old Waldorf-Astoria was demolished to make way for this definitive skyscraper. It was completed in 14 months, at a rate of about four and a half stories a week, during an aggressive race to build the world's tallest structure. Empire State stories: The top floor was intended to be a mooring dock for dirigibles; in 1945 a bomber sideswiped the 79th floor. There are two observatories, on the 86th and 102nd floors. *Landmarked 1981.*

13. New York Public Library
(1898–1911), *at 42nd Street*. One of the finest examples of Beaux Arts architecture in America, this Carrère & Hastings building occupies the former site of the Croton Reservoir. The results of a $45 million renovation program begun in 1982 are now strikingly obvious in the restored entrance and exhibition halls. The library should take its place at the top of any visitor's list. *Landmarked 1967.*

14. Seth Thomas Company sidewalk clock (c. 1907), *at 44th Street*. *Landmarked 1981.*

15. Rockefeller Center
(1931–55), *at 50th Street*. It took three architectural firms to create this 19-building, 22-acre masterpiece of modern urban development. The 14,000-pound bronze Atlas fronts the International Building. *Landmarked 1985.*

16. Rizzoli Building
(1907–08), *at 55th Street*. A shopping center and 48-story tower will be built behind the joint facades of the Rizzoli and Coty buildings, which were saved only at the last minute in 1985. (Close by, at 54th Street: McKim, Mead & White's High Renaissance University Club.) *Landmarked 1985.*

17. Plaza Hotel
(1905–07), *at 59th Street*. New owners Donald and Ivana Trump promise to return the hotel to its original spun-sugar splendor. There's some uncertainty, however, about whether the Tiffany ceiling in the Palm Court will be restored; the dome of leaded glass was pulled down in the 1940s. Still, it's a nice place to stop for afternoon tea. *Landmarked 1969.*

18. Metropolitan Museum of Art
(1874–present), *at 82nd Street*. The 1970 master plan for the Met's expansion will be completed next year with the opening of the decorative-arts wing. The main building (central facade by Richard Morris Hunt, with wings—the corner of the southern one shown here—by McKim, Mead & White) surrounds the Victorian Gothic original, which in turn is surrounded by various additions, including the Roche-Dinkeloo glass hangars of recent years. *Landmarked 1967.*

JOHN GRIMWADE AND CHIKO WAKABAYASHI. RESEARCHED BY JOHN FENDRICK.

Architectural illustration

LIKE MOST AREAS OF TECHNICAL ILLUSTRATION, a great deal of specialized knowledge is required in the field of architectural illustration. Drawings or artist's impressions will have to be made often from nothing more than a set of plans and an architect's sketch. Even if the subject to be illustrated is a simple exterior view of a house, the illustrator must have sufficient knowledge to make it accurate. Some illustrators use computers to "explain" plans in print-outs and then work over these machine drawings, which can, of course, be updated if the plans change.

Architectural illustrators are frequently employed on a full-time basis by large practices. Most architects can themselves draw very well, and many illustrators whose work concentrates on buildings, will have attended architecture school.

There are two distinct types of architectural illustration. First are those illustrations that are usually commissioned by architects themselves. These are, by and large, black and white drawings, which are extremely accurate to the architect's intentions and which have as little distracting imagery, such as figures or landscaping, as possible.

Second, there are those drawings commissioned for a more general use. This area includes historical reconstructions of buildings or towns and artist's impressions for property developers' brochures. These brochures exist long before the buildings, so the illustrators have to work from plans and elevations, or even models, to create a convincing picture of how the project will look. These are invariably in colour and include such details as people, animals and trees.

Both approaches demand a knowledge of perspective and the ability to read and translate plans.

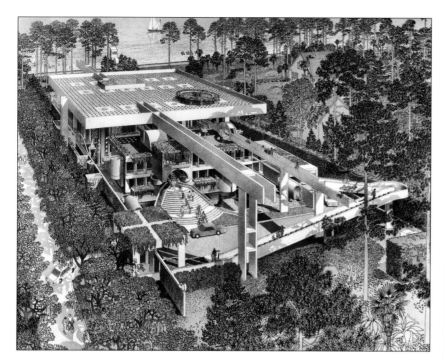

Left An illustration by Helmut Jacoby of a beach house in the USA. To be fully appreciated, this extraordinary drawing needs to be seen much larger than it can be reproduced here. Painstakingly done in pen and ink, with airbrushing for colour and contours, it is an extremely realistic view of the finished building.

Left These roughs, from a set done for a client who produces building materials, were prepared so that a style for a finished illustration could be selected. **Below** is one of the finished illustrations showing the more detailed style that was adopted.

Right Another drawing by Helmut Jacoby, this time of a tower block in Frankfurt. The realistic style gives an accurate impression of the proposed building and its setting.

Maps and diagrams

INFORMATIONAL ILLUSTRATORS ARE OFTEN called on to draw maps, so it is essential that they have some cartographic knowledge. A different projection of the world or a statistical view of countries that results in a change in their relative sizes may be required. This is a highly specialized task and requires an expert.

Making diagrams interesting requires a certain type of thinking. The ability to conceptualize an approach that makes dry statistics come alive is essential to a good informational illustrator.

Below Putting statistics or tables into relevant imagery is a technique often used by informational illustrators, especially in magazines. This ship motif enables the reader to see the information in an easily assimilable form.

Above A poster map of the wine-growing areas of France. This is an interesting example of informational illustration that, as well as being accurate in its delineation of wine-growing areas, uses evocative paintings to convey visual impressions.

Left A spread from *Esquire,* which accompanied an article on the wedding of Michael J. Fox and the elaborate security precautions needed to foil the plans of the *National Enquirer* to get pictures of the event. Illustrator Clive Piercey, an Englishman living in Los Angeles, manages to compress a lot of information into the spread by a graphic use of symbols, most of which were on overlays on top of a base drawing in pencil.

Right and below The colour was specified and, apart from the colour symbols in the boxes, was added by the printer. All the small symbols were done as separate pieces of artwork, which were placed in position on overlays.

HELICOPTER PAD

CEREMONY SITE

CHECKPOINT

DECOY VEHICLE

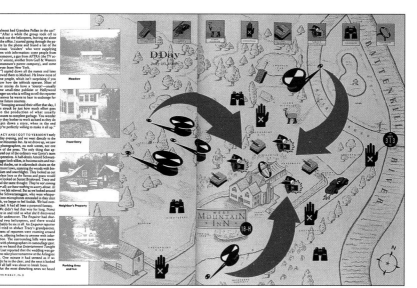

Left The illustration as it finally appeared in the magazine, with the addition of actual photographs of the location. Not only does it support the written explanation of events, but it also varies the mainly photographic tone of the rest of the article.

Medical illustration

AN INCREDIBLY SPECIALIZED FIELD, medical illustration involves years of post-graduate study, but scientific training is only one step towards being a medical illustrator. An imaginative use of these technical skills is equally important. Many medical illustrators are employed on a full-time basis by hospitals and training schools.

If you are commissioning a book that contains medical illustrations, you may find that the author has previously worked with medical illustrators and may be able to provide you with useful contacts.

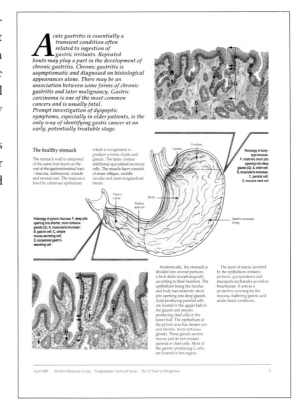

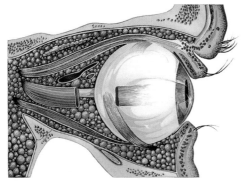

Right Colour (gouache in this case) is used to delineate clearly between different parts in a cross-section of an eye. To appreciate the extraordinary level of detail shown here, reproduction at a much larger size is required.

Below An illustration of three cross-sections of the growth of a hair follicle, in which colour is used to carry information about different skin types. This illustration has been done with a mixture of airbrushing and painting.

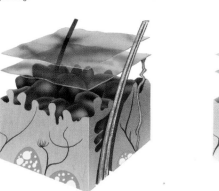
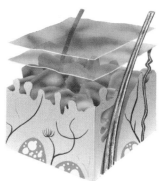

Above A page from a medical educational partwork, which shows a fairly straightforward type of linework. The illustrator has to find a way of achieving tonal variations and "modelling" while using only black and white.

Far left This drawing of a man's skeleton and muscle configuration has been done in pencil with a light watercolour rough. Not only is it medically accurate, but it has a lovely, "drawn" quality and shows that medical illustration does not have to be dry and static.

Left and below An original illustration and the printed version as it appeared in a medical handbook. The illustration has been scanned and placed in the layout with the positions of the two brains changed from where they were on the artwork. Medical textbooks rely heavily on illustration, as can be seen from this spread.

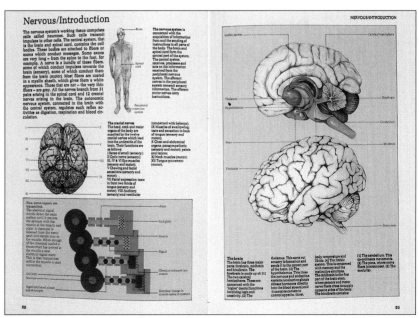

Botanical and natural history illustration

ILLUSTRATION OF BOTANICAL and natural history subjects ranges from encyclopedias and children's reference books to scientific treatises. Research is an important element of the natural history illustrator's work since it forms the very basis of their subject. Such illustrators also need to understand design and typography, because, just as in technical drawings or maps, natural history illustrations often require detailed annotations or keys. Again, you must look to the experts for advice, for a satisfactory combination of all these disciplines is rarely found.

Right Two adverts from a series on conservation by BP, illustrated in an accurate yet atmospheric way. Note the way that the text is kept minimal and the typography "bookish".

KESTREL
FALCO TINNUNCULUS

The number of kestrels in Britain was on the decline during the 1960s but they have recovered to become the most widespread of our birds of prey. Their characteristic hovering hunting technique is a common sight to the motorway driver. They are even nesting in central London. BP's Head Office near Moorgate has the honour of being host to a breeding pair.

HARE
LEPUS CAPENSIS

The brown hare is found all over Britain, mainly on farmland and especially on open pasture, but less commonly than it was. No other wild animal has so captured the imagination – the hare features in tales and songs and is strongly associated with magic – and yet remained so elusive.
The UK's first commercial oilfield was discovered in 1939 in the countryside around Eakring. Although the original well-sites are no longer producing, 'nodding donkeys' are still part of the landscape of Nottinghamshire.

Below Standards of illustration in the fields of botany and natural history are extremely high. The subjects are drawn from life so detail and observation are paramount. There is less room here for quirks of style and personality.

Below A design-group packaging project that required accurate and clear illustrations to convey the naturalness of these apple and orange juices. The botanical illustrations, which are very classical in spirit, are beautifully rendered by Rosanne Saunders, and the typography supports this look.

Information illustration

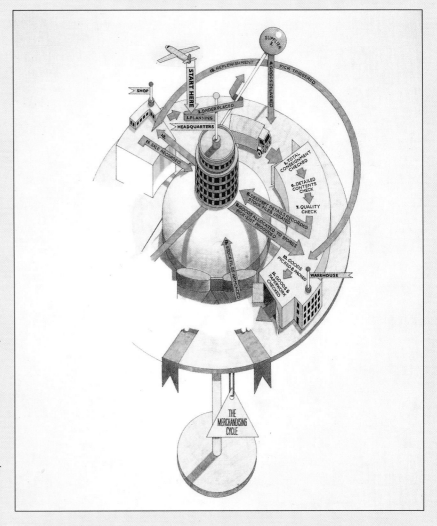

INFORMATIONAL ILLUSTRATION IS used in many places – here it is part of an annual report and is being used to give shareholders an insight into the workings of a certain division in the company. David Stocks at Michael Peters Literature was the art director, and each section of the report had some form of illustration in a wide range of styles. The brief was very much a "nuts and bolts" affair. The company wanted the information, a complicated flow chart, to be communicated but needed it to be done with the stylishness of the rest of the project.

The illustration had to show the cycle of merchandising – how Burtons sells goods in its shops. The company developed a system of making sure that all its stock is very tightly monitored, so that whenever anything is sold in any of the shops, a computer system triggers replenishment of that item from the storehouse.

David Stocks had been looking at the work of Grundy and Northedge Designers, and he saw in their approach to visualization and symbols the solution to his problem. He gave them a simple flow diagram of the relationship between headquarters and suppliers, but they felt that it needed to be made more interesting and relevant to the client. So, as Burtons was in the business of selling wearable goods and given the cyclical nature of the process, Tilly Northedge came up with the idea of a hat on a stand. She used the brim of the hat as a basis for displaying the diagram, while the crown of the hat provided a suitably central point for the management office and the brim was used for the ware-house. The supplier is outside the system so was depicted by a hat pin. A sales tag carried the title.

David had given them a rough size at which the illustration would be used, and the style of the report was such that it could be set in a generous amount of white space. Tilly Northedge: "It was important to know the size that it would be used as the complexity of the diagram depended on that. It was also important to know what the reduction was going to be for the typesetting."

Above A full-colour, partially completed rough, drawn in pencil. There are small changes between the rough and the finished art-work. The building, originally called "Headquarters", was re-titled "The Central Merchandising Team Systems Centre", and the new name had to be accommodated, which unfortunately covered up some of the drawing detail.

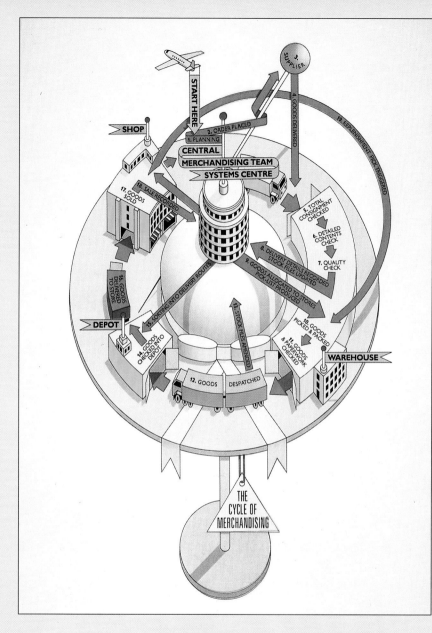

The rough was done up to the point at which it would be submitted to the client for approval – an art director has the visual sense to fill in the gaps. If they had been dealing with the client direct, it would have been necessary to have shown the completed diagram because it is unlikely that the people who had to approve the rough would have had sufficient visual understanding to have seen beyond the first outline stage.

There are small changes between the rough and the finished artwork. The title on the headquarters became much longer and extra typesetting had to be accommodated, although it unfortunately covers up some of the drawing detail. The way in which the words "Replenishment Pick Triggered" broke was agreed to be awkward, so that was also amended.

Above The finished artwork. The colour was airbrushed onto paper, and the line work and type were on Kodatrace overlay. Tilly Northedge asked for the title "The Merchandising Cycle" to be changed to "The Cycle of Merchandising" because it fitted better into the shape of the tag.

Right The finished page in the brochure, with the type deftly running round the illustration.

ADVERTISING AND GRAPHICS

THE VERY NATURE of the media tends to mean that advertising illustration is non-controversial. It is there generally to promote or sell something. Illustrations need to be appropriate, of course, but also to be quick to read and to appreciate. It is also important to remember that any advertising commissioning involves several people; as we have already seen, quite a number of people have to give their approval for any illustration to go ahead.

However, the needs of advertisements – to sell and to promote – do not necessarily inhibit good commissioning of illustration. Although advertising is rarely a breaking ground for new talent, it is a field in which illustration can have a big impact. The impression made by a full page in a broadsheet newspaper or a 48-sheet poster site in a high street cannot be gainsaid. The audience for these showcases of illustration is immense.

Right A wall mural designed by Mark Harfield. His usual medium is Letratone (adhesive coloured film), which he cuts out and "paints" with. Here, his illustration has been blown up and silkscreened onto panels to achieve this vibrant and exciting mural.

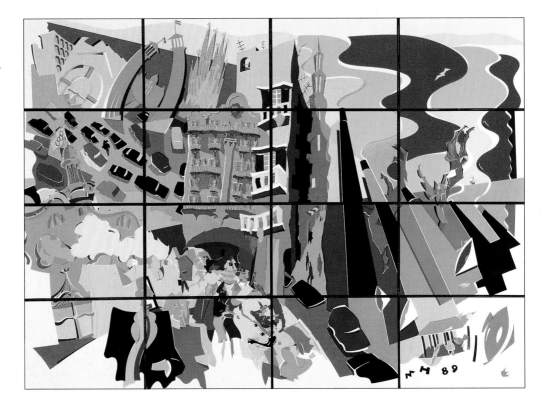

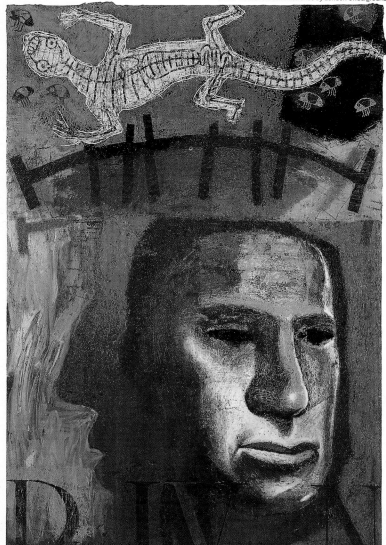

The Museum of Mankind, by Tube

Burlington Gardens W1
Nearest stations: Green Park & Piccadilly Circus

Diviner, Mask and Lizard by Tom Wood
A new work of art commissioned by London Underground

© London Underground Limited

Left One of a series of posters for which London Transport has reactivated the tradition of commissioning fine artists and illustrators. Here, artist Tom Wood has been given the task of illustrating the Museum of Mankind. The strength of this particular poster comes not only from the powerful face, but also from the composition of the elements. It's a shame that public bodies do not commission more art for display in public places.

Below Two greetings cards from a series that use parodies of kitsch 1950s commercial art to create amusing images. This type of parody depends to a great degree on the copywriting.

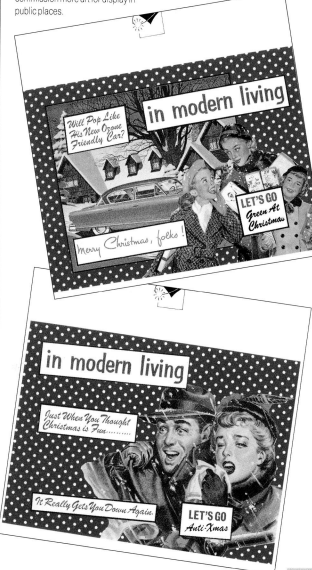

Advertising

WHEN COMMISSIONING ILLUSTRATORS for advertising work, agency art directors follow an entirely different approach from other commissioners. Having worked out some idea of the style of illustration required, he or she approaches the in-house art buyer. The art director deals solely with the creative side of a project. It is the art buyer who has the necessary knowledge of illustration and photography and who has the all-important contacts. He or she handles all the negotiation of fees, the schedules and reproduction rights.

At the beginning of a project the art director and buyer will discuss the requirements of the illustration and, either together or separately, consult reference books and illustration files. The relevant portfolios are gathered by the art buyer, and from these the art director makes the final choice. Sometimes the client wants to approve this choice before giving the go-ahead. The illustrator will then be approached to discuss ideas and fees.

This page A series of advertisements for cosmetics that was based around lines from famous songs. The illustrations look as if they have been done with the actual make-up, and the style is evocative of the period the songs come from. Here the illustrations are at the service of the overall concept that was devised by the art director and copywriter.

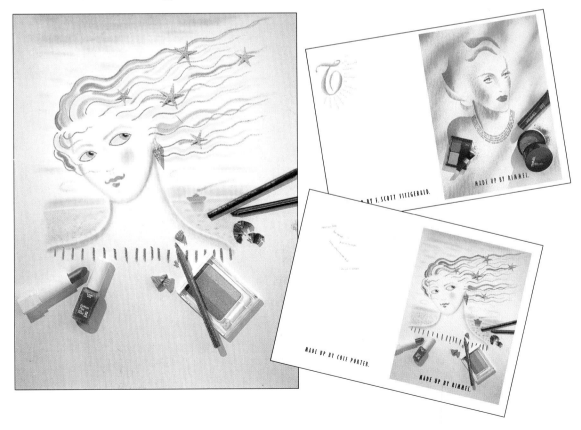

Later on in the process, the art buyer acts as a buffer between the production department, the art director and the artist. The art director is further protected by his or her account director, who is the chief means of liaison with the client. All this assistance allows the art director to devote the majority of his or her time to collaborating with copywriters and working on new ideas.

A lot of time and effort goes into even relatively small advertisements. A great deal of money is involved in the advertising world, and all good agencies like to feel entirely satisfied with the end result. They take no chances, so any illustration work is, generally, heavily art directed and can involve many amendments.

In this area illustrators do not have much scope to input their own ideas. Indeed, it is not unknown for agents to be sent roughs for advertisements that slavishly follow the styles of illustrators they represent. All that the illustrators have to do is copy the roughs in their own inimitable way and deliver the job. In a sense, this is *illustration* as it is defined in a dictionary, and who is to say that it is a bad thing if the end result works?

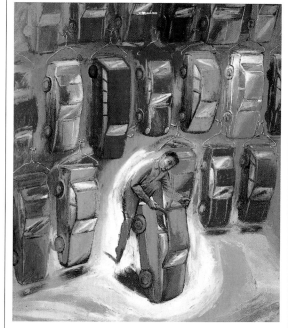

MEET A CAR MADE FOR YOU AT
M O T O R F A I R
Earl's Court 19–29 October 9.30am – 7.30pm (closes 5pm final day).
Public preview day Thursday 19 October. Motor Sport day Tuesday 24 October.
Credit card bookings 01 379 4444.
THE LONDON Motorfair 89 MOTOR SHOW

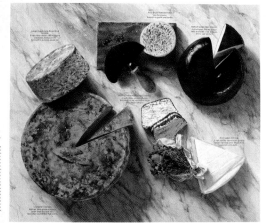

Above It's unusual to see such an "editorial" illustrator as Robin Harris used so boldly in advertising. He was given quite an open brief and actually did the painting in a room at the advertising agency's offices. The quietness of the typography frames the image beautifully. The only fault is the slightly arbitrary positioning at the top of the "I Love Lead Free" logo, which was presumably placed there at the client's insistence.

Left Illustration is used in an almost photographic way in a layout that mimics an editorial spread in a magazine. It's actually hard to work out why, apart from budgetary constraints, illustration should have been used instead of a photograph.

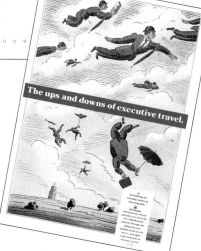

Above Editorial style is used effectively to illustrate a concept. The simplicity of the drawing is its strong point, and is sits well with the straightforward headline.

Packaging

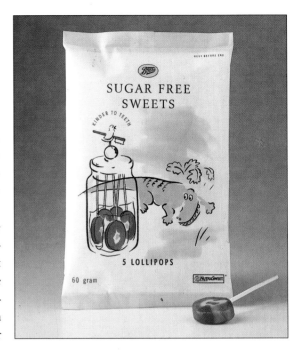

MOST PACKAGING WORK is done by design groups, although large companies may have specific departments whose function is to design packaging exclusively for the goods manufactured or sold by that company.

Illustration is an ideal vehicle for conveying the mood that will set a product apart from its competitors. It is also a good way of idealizing a product without conveying falsehoods and without the sometimes alienating hyper-realism of photography. An illustrator's sense of style can enhance a mundane product, give it a contemporary look or

Below Carrier bags are an excellent means of communication, yet surprisingly few are illustrated. Here are two from a series used by a stationery and book store. The whole series was based around the use of faces, and simple, bold ideas, printed in two colours, work very effectively.

Above This packaging was designed to appeal to children and is very much in the airy, light style of the late 1980s. Typographically very straightforward, the package is carried visually by the illustration.

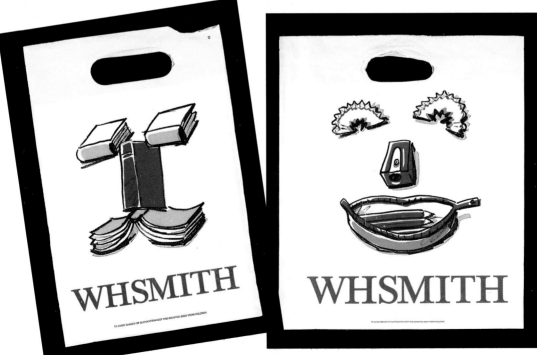

make it appealing to a particular band of consumers. Children's food, for instance, relies heavily on "user-friendly" cartoon drawings.

Illustration can combine elements in a way that seems very natural; a detailed study of a fish and a scene of fishing boats on the sea can be drawn in a way that looks unforced. Illustration is also sympathetic to the designer's use of colour. If a product is strongly associated or identified by a combination of colours, it is much easier to integrate these colours into an illustration than into a photograph.

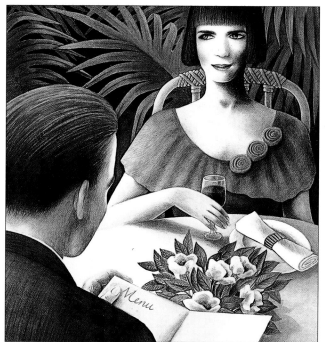

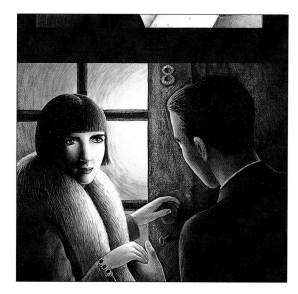

Right An unusual series of wine labels was devised in partnership between designer and illustrator. The labels, which were produced as part of an illustration course project, work as a narrative series: boy meets girl, they dine, dance and go home.

Although these particular labels were not produced commercially – they were used in an in-house bar at a design group – this is an area in which illustration is now used as a matter of course, especially by supermarket chains.

Packaging

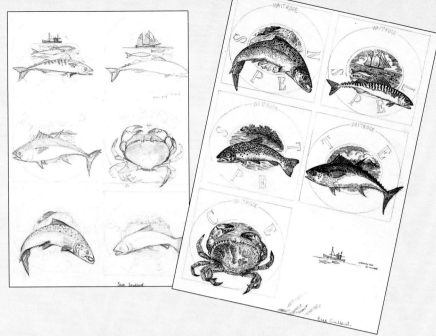

THE BRIEF FOR THIS GROUP of six packages for fish patés was to produce a visual image that reflected a traditionally made, high-quality product. To achieve this feeling, art director Chloë Alexander chose Thomas Bewick's engravings as a starting point for her search for an illustrator. She was keen to use someone who would do an actual wood engraving rather than a pen and ink facsimile. Sue Scullard was recommended by a colleague as having a traditional wood engraving technique, but with a slightly looser, more decorative approach. The design of the packaging was very precise and required the illustrator to work accurately to pre-determined spaces. The roughs showing the type in place were sent to Sue, and she slotted in the imagery.

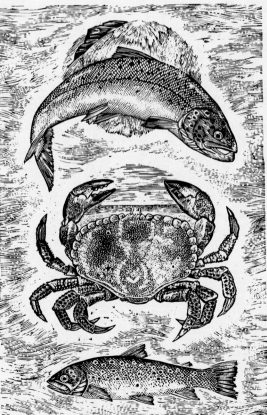

Above Sue Scullard's first roughs were done in pencil, then in pen and ink. They follow very closely the tight design that the art director had indicated in her roughs.

Left A pull from the block. Sue Scullard does not have a printing press, so these pulls were proofed by hand, using a spoon to rub the paper against the block.

Above An original engraving by Thomas Bewick (1753–1828). His work was the inspiration behind the style of illustration used for this packaging project.

Below The final roughs for five of the packages. A few minor changes were subsequently made, as can be seen in the finished design, **left.**

Above Printer's proofs of the packaging before scoring and folding. The illustrations are set off effectively through the use of flat colours, which contrast with the incredibly detailed wood engravings

Packaging

THE Tohato Confectionery Corporation of Japan wanted to develop new lines of cookies using various artists. Their first series used the Japanese painter/illustrator Hibino, and for the second they chose French illustrator Isabelle Dervaux. The Japanese always pay special care to packaging, and boxes such as these are perfect gift items in a country where gift-giving is an institutional custom for business and social relations. Western-style cookies have been recently introduced in Japan and are very popular among teenagers and young women.

There exists in Japan a big demand for 'character goods' – products in which an illustrator's name and work is used to create a strong identity. Japanese clients don't like to put too many constraints on Western commercial artists, so the brief was left very open. When Isabelle Dervaux started work she was asked to conceptualize a package for an unspecified confectionery product, that would appeal to the young Japanese market. Three different concepts were submitted; the idea based around the line 'What is your type?' was chosen, and the five basic shapes were decided upon. With the help of art director Sophie Le Fevre, actual size mark-ups were built, with cookies moulded out of clay in the shapes of the characters drawn by Isabelle. This idea proved to be too expensive so the standard cookie shapes were chosen instead. Sample aluminium boxes were made and sent to America for Isabelle to further refine. The new prototypes were then used for market research in Tokyo. The assignment was completed with Isabelle spending a month in Tokyo with the client and the can maker.

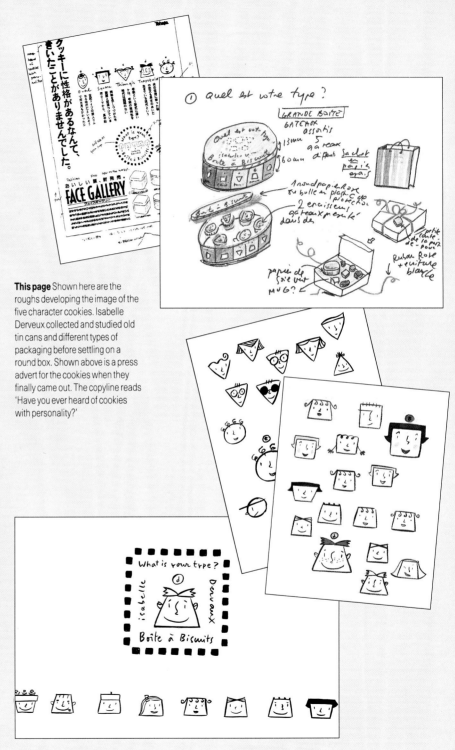

This page Shown here are the roughs developing the image of the five character cookies. Isabelle Derveux collected and studied old tin cans and different types of packaging before settling on a round box. Shown above is a press advert for the cookies when they finally came out. The copyline reads 'Have you ever heard of cookies with personality?'

Right A colour rough for the tin containing five different types of biscuit, which is quite faithfully translated, albeit with slightly different colours, into the final tin.

Left The five individual tins, each containing biscuits of different shapes. Instead of using the four colour process, the cans were silkscreened twice – first with a coat of white, then with the actual colour, to ensure brightness. The cans are actually wrapped in a coloured sleeve for protection.

Fashion

THE FASHION INDUSTRY uses illustration in two ways. The first is when garments or accessories are drawn for publicity purposes. Sketches are used because the line of the clothes often suits a "drawn" look. In addition, drawings can be used to contrast with glossy fashion photographs.

The second use of illustration is when the style of a particular illustrator fits in with the image that the designer wants to convey. This may not even mean drawing the clothes; instead it may range from creating a chic identity for carrier bags to painting murals on the walls of a showroom.

Right David Hiscock's photographic series for Mansfield clothes had a strong illustrative element. This is part and parcel of Hiscock's style, and is also due to the fact that the images in this campaign were inspired by the paintings of Gustav Klimt.

Right Illustration used as a witty element of a larger concept. This is particularly unusual in fashion advertising – usually the concentration is on the clothing or on creating a relevant atmosphere. Tony McSweeney's deft pastiche of turn-of-the century illustration fits perfectly with the copy line.

IN SHEEP'S CLOTHING.

BEWARE OF THE WOLF

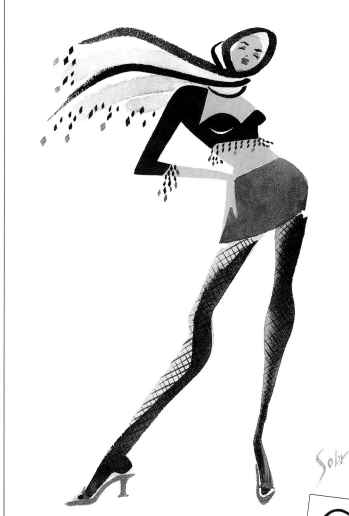

This page Fashion illustration by Penny Sobr: stylish, but without sacrificing a sense of how the clothes actually look. These are for advertisements, but work equally well in an editorial context.

T-SHIRTS

T-shirts are very much a part of fashion. Only illustrations in a current style tend to be used as they have to fit into the narrow requirements of the market place. Occasionally something more interesting will get printed: this is usually when illustrations are used to focus attention on an issue currently in the news, and there is something more to them than just a pleasant image on a shirt front.

Company reports and brochures

AN AREA OF INCREDIBLE GROWTH in the use of illustration, company reports are now corporate brochures. Companies have become increasingly aware that a dry presentation of statistics at the end of the year is not enough and is, indeed, squandering a very useful communication tool.

Illustration is often used to explain the workings of the company to its stockholders, giving them an insight into how the company is made up. It can present this information in an attractive, easy-to-read way, bringing together a variety of visual symbols to create a coherent and impressive message. Illustration can respond to the style that the company wishes to present, making it imposing, friendly or adding a welcome touch of humour.

BROCHURES

Successful illustration in brochures is more often used in a decorative capacity – brightening up borders and page corners – than as the main pictorial

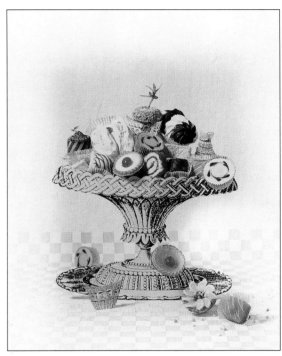

Left and above Hannah Toft's illustration for an IBM quarterly report is from a piece about systems integrators and data processing. Following on from the headline "A Recipe for Success", however, the illustrations are all based around food images. They are a mixture of cut-out, blown-up etchings and real objects rephotographed.

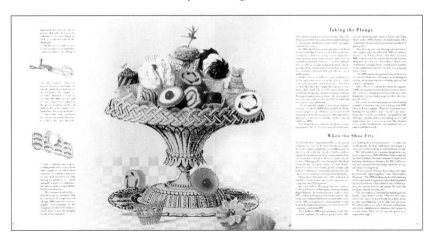

element. The main function of a brochure is to sell something to the consumer, and the favoured vehicle for this is photography because people want to see exactly what they are buying. Illustrations are often used as signposts to particular sections of a brochure, helping to point the reader in the direction of salient information.

There remains, unfortunately, much use of what could be called the "Letraset" style of illustration. This is usually found in brochures from minor tourist boards, cleaning firms and DIY superstores.

Right These woodcut illustrations by Christopher Wormell, which were used same size, give an established feel to this company report. Although they are small, the design of the pages and the amount of white space that is left allows them to stand out and set the overall tone.

Above and right Pages from a copiously illustrated public relations brochure – how different from company reports from as little as six or seven years ago. The services dealt with by the company are referred to in the relevant illustrations, which use a mixture of techniques involving drawing and printing. They transform what could have been a fairly dry package into something that is lively and interesting.

Advertising poster

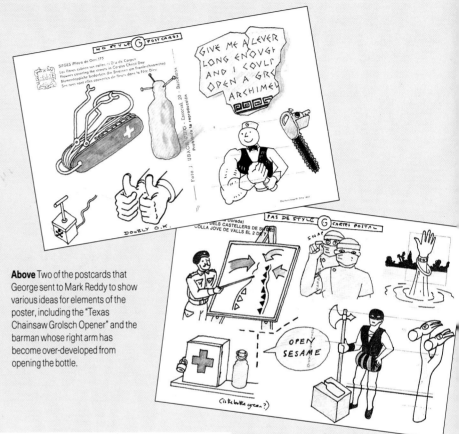

TWO ILLUSTRATIONS in the Association of Illustrators' annual that George Hardie had done for a Danish shipping company led Mark Reddy (at advertising agency Holmes Knight & Ritchie) to choose him for a beer company's poster campaign. As it was entering a new market, the company needed something to set it apart from other brands, and Mark had based a TV campaign around the supposed difficulty of opening the strange clasp on the bottle.

A 48-sheet poster, which was the size the client wanted, is the largest size of poster displayed. George Hardie: "I'd never done one and so I was very excited. Mark said it was needed very quickly – all the roughs in a fortnight. I was going on holiday

Above Two of the postcards that George sent to Mark Reddy to show various ideas for elements of the poster, including the "Texas Chainsaw Grolsch Opener" and the barman whose right arm has become over-developed from opening the bottle.

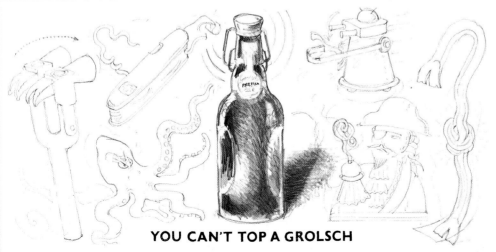

YOU CAN'T TOP A GROLSCH

Left The final, amended rough for the job which was accepted by the client.

the next day to Spain, but I said 'yes' because I really wanted to do it, and I sent him a postcard every day."

These postcards kept the job on the boil. When George returned there was a discussion about the two types of idea he had come up with: the first, in which opening the bottle bent the tool, and the second, which showed all the possible ways of opening the bottle. The Swiss Army Knife is an example of the former, and "magic might have solved this task", the latter. After discussion, they ended up with more broken tool ideas. George did a rough in two days, but the client felt it was much too complicated. Mark Reddy sent George a rough showing the pack in the middle and a much simpler approach.

Below George Hardie was having a great deal of difficulty drawing a pirate that he liked, so he turned to fellow illustrator Malcolm Harrison, with whom he shares a studio. He wanted the type of illustration that used to appear in Enid Blyton books, so Malcolm did this, and George traced over it with a pencil in an attempt to achieve a brush-stroke look (as he couldn't do it with a brush!).

Below The finished artwork, done on a sheet of paper about 30in (75cm) long. It is hand-painted as the artwork was needed quickly. George generally prefers to have the line artwork printed cheaply in various colours and to collage these.

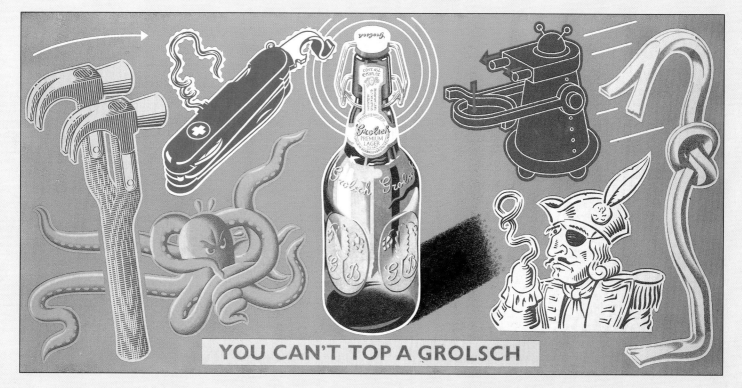

YOU CAN'T TOP A GROLSCH

The music industry

THE PROLIFERATION OF DIFFERENT FORMATS for carrying music demands that art directors commissioning covers need three versions of a piece of artwork or, at least, an illustration that can be successfully cropped in three different ways: the LP format is square, the music cassette is rectangular (a ratio of 1:1·57), while the compact disc is also rectangular but to different dimensions (a ratio of 1:1·17).

Many of the works of the great classical composers have been recorded dozens of times, and one of the ways to set a new version apart is visually. There may be a shortage of pictorial references, and the same portraits have been used countless times, so illustration is the ideal way of presenting a new version or of highlighting a contemporary recording.

In the music field illustrative styles are often used because they are "of the moment". Today's most popular style would appear to be collage. Illustrators are sometimes called on to "treat" a photograph of the recording artist as a way of giving a new slant, and a cover illustration can give an up-to-date, current image to a face that has been around for a long time. In a media where image is so vital, this can be invaluable.

In many cases the client is not only the record company; it is also the musician(s) and their management. Everyone wants their say and feels very strongly about the results. The artiste may indeed have come up with the original concept, and this can present a formidable barrier to the illustrator, who wants to have a great input in the final image.

Because both music and illustration can be so evocative in their different ways, they suit each other very well. Some fine experimental and abstract illustration has been done in this field recently. In some cases the brief must have been little more than for the illustrator to listen to the piece of music. Here the art director's main effort is directed towards finding illustrators who empathize with the style of music being illustrated and whose style seems somehow relevant.

Right Quiet typography contrasts with a turbulent image, by Colin Williams, on this album cover. With a lesser-known musician the manner of illustration can help to give a clue to the style of the music.

Left Two covers for different singles from one period in an artist's career, display a consistency of visual approach. The design and illustration work in tandem to create a definite feel.

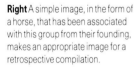

Another simple, striking image, this time designed to create a "primitive" feel for the record cover.

Right A simple image, in the form of a horse, that has been associated with this group from their founding, makes an appropriate image for a retrospective compilation.

Record and cassette cover

THE PROCESS OF COMMISSIONING a CD and cassette cover for a piece of classical music is explained by Ann Bradbeer of Decca Records. "The projects get off the ground with marketing meetings at which we discuss all the releases. It is here that the decision is made whether to put a photograph on the cover. If we decide not to, we will commission an illustrator. We then research the subject and listen to the music before looking through our reference material and calling in portfolios."

In this case the illustrator Dirk van Dooren had come in the day after the meeting to show Ann his portfolio. "In it, I had seen a poster that Dirk had done for Quad stereos, and I thought this style would match one of the covers that we had to do – *Romeo and Juliet*. He uses flower and plant imagery – very appropriate, without spelling out the romantic, slightly pathetic story." Ann felt that one section of the illustration should be left relatively uncluttered for the type. "Dirk showed me a very finished rough of how it would look after about two weeks. What he came back with was perfect – some painting, a bit of Botticelli, a Romeo-esque type figure and a cosmic moon. For the finished artwork he only had to do a bit of varnishing and some fine-tuning. I requested hardly any changes."

Cassettes tend to be something of an after-thought. Of the several formats to be considered, the CD is the biggest seller and that is where the commissioning starts. When the art director sees the rough, it is important to bear the cassette in mind and discuss cropping or a further piece of artwork.

Above The original artwork. Dirk van Dooren: "I couldn't have explained properly with a rough. I go for the knockout punch, if you like, I worked out the ingredients for the recipe; a man and a woman in some form, symbols of love, science and art."

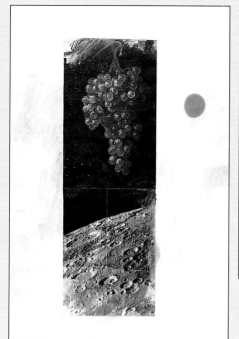

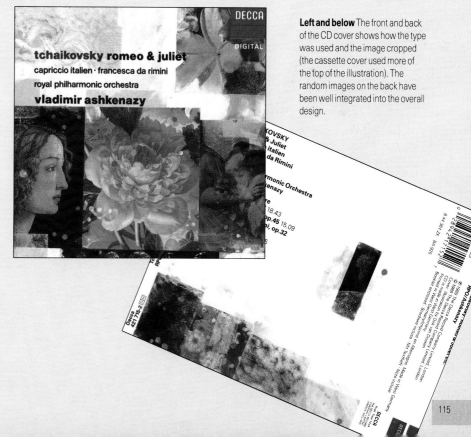

Above Dirk: "I wanted to do more than just a cover image so I suggested some extra elements – without really knowing how they'd be used."

Left and below The front and back of the CD cover shows how the type was used and the image cropped (the cassette cover used more of the top of the illustration). The random images on the back have been well integrated into the overall design.

tchaikovsky romeo & juliet
capriccio italien · francesca da rimini
royal philharmonic orchestra
vladimir ashkenazy

DECCA
DIGITAL

A second piece of artwork is preferable so that the original is not just cropped to the cassette ratio and therefore looks more considered.

"I made a transparency and put together a visual to show the marketing department. One of their main concerns, unfortunately, is the type size of the artist's name. This one is discreet but with a simplicity and a placing that makes it appear quite bold. The visual was approved and sent to Vladimir Ashkenazy. He's fairly difficult to track down, but he wrote back, saying that he liked it." The overall time allowed for the job was about four weeks.

Posters and calendars

Below Two posters in which illustration provides the main focus. The War on Want poster uses a John Heartfield-style photomontage to get its message across quickly and simply. You almost know what the headline will say after one quick glance at the image. There are no distractions – no colour, no large type. The film poster, *Five Corners*, is not dealing with such an identifiable subject, but it is so striking that it engages the interest of anyone passing by, even if they are only trying to work out what is going on. The illustration was done by the designer himself, Martin Huxford, with a large debt to Keith Haring.

POSTERS ARE AN ART FORM in which illustration has been used boldly and strikingly. Sometimes the need to sell a product is paramount; sometimes a poster is used to attract and entice; sometimes the need is simply to inform. Whatever their function, they are all around you, at their best bringing an art gallery to the streets and into the underground.

The most important factor for the art director, of a poster to consider is the legibility of any text in relation to the site the poster is on. Art directing

Right An advertisement for two different drinks from the same maker, illustrated by Bush Hollyhead. This is a good example of a job for which illustration is unsurpassed – a photograph attempting the same thing would probably be rather forced and stagey, as well as being extremely expensive and difficult to do.

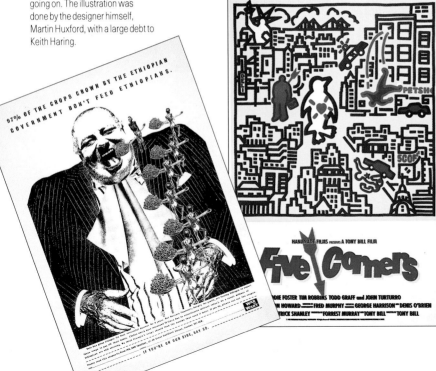

HANDMADE FILMS PRESENTS A TONY BILL FILM

Five Corners

DIE FOSTER TIM ROBBINS TODD GRAFF and JOHN TURTURRO
N HOWARD FRED MURPHY GEORGE HARRISON DENIS O'BRIEN
RICK SHANLEY FORREST MURRAY TONY BILL TONY BILL

97% OF THE CROPS GROWN BY THE ETHIOPIAN GOVERNMENT DON'T FEED ETHIOPIANS.

WAR ON WANT

a poster for the front or side of a bus will pose a different set of problems from those for one that is for a stationary billboard. A subtle drawing will be wasted on a "moving" site but will suit the commuter who is waiting for an underground train and has time to appreciate it.

Some posters – those for charities, for example – are handled in an editorial way; some – those advertising low-key subjects like underground destinations – in a decorative way; and some – regular advertisements that are attempting to make you buy something – are treated in hard-sell way. This breadth of subjects and uses for posters means that there are always exciting examples to be seen.

CALENDARS

BECAUSE CALENDARS ALWAYS have a theme, publishers tend to have a definite idea of their potential audience. Illustrated calendars that are commis-

sioned from scratch are quite rare. Those produced for the mass market are often compilations of cartoons or "found" illustrations, and often the most interesting examples are produced as promotional items by printers and design groups or as corporate publicity.

The challenge in directing illustrators who are contributing to a calendar is to keep some coherence and flow throughout twelve separate images. Even with one illustrator this can be a problem; with twelve separate illustrators, each with a distinct style, it becomes much more difficult. The style of the type and the design of the pages can hold the different images together, while using a standard format to which all the illustrators must adhere can have the same effect.

Below An image from a calendar sent out jointly as publicity by a design group and a printing firm. The illustrators of the 12 months (here it is New York-based Philippe Weisbecker) are given a free hand to interpret the month within the overall theme of the calendar. The design of these calendars is always free, often with subtle touches, like the stencils on this page.

This is how the illustration ...ed on poster sites. The ...y has been left to insert the ...on the bottles, and it has ...ed the illustration into a thinner shape, which suits the elongated form of the tiger. The colour is relatively accurate, but the image is slightly washed out compared with the original.

TV, FILM AND VIDEO

WHEN IT IS ART DIRECTED, illustration is generally used in a static medium – with text in a book or brochure or on the jacket of a book – and this is where the illustration ends. When it is used as the basis for animation, however, the illustration is only the starting point of the idea or the subject of the film or video.

Not all animation is drawn; there are other major areas such as modelmaking or the animation of objects. In those fields that do involve illustration, however, the artists fall into two categories. Some animators are illustrators who work only with moving imagery; others are illustrators who usually work for print, but occasionally become involved in animation. Most often they are commissioned by advertising agencies for television commercials or by design groups working on films for corporate training.

Above and right Two frames of animation illustration created on computer for the credit sequence of the Paul Daniels Magic Show on television. This standard of realism would be prohibitively expensive to achieve by traditional methods.

Right Four images – strictly technical illustrations taken into the medium of animation – from a presentation to medical students. By the visualization of certain elements and an imaginative use of colour (such as the depiction of enzymes, near right), the film manages to convey complex physiological concepts in a clear manner.

triglyceride
protein

Above Another example of imagery drawn on computer, this time for an advertisement. Much of this animation has an airbrush look to it, which is appropriate as it is dealing in hyper-realism.

Commissioning for animation

THE COMMISSIONING PROCESS can work in several ways. The art director may know which illustrator is right for the project and will liaise between him or her and an animation company. Alternatively, the art director may hire an animation company to do the job, and the animators may decide that they require an outside illustrator to achieve the perfect style for the art director's storyboard. They will then suggest this to the art director.

As with any creative process, the art director is in the hands of those artists that he or she has hired to carry out the brief. As animation is an extremely time-consuming and costly process, however, deciding which animation company or illustrator to use is crucial. From the outset the art director must have a very strong idea of the general look of the project and must hire people that he or she trusts.

Once the concept, script and storyboard have been worked out, the illustrator and animator have to realize it in a convincing manner. The illustrator will probably have no real knowledge of timing, editing, camera positions and the use of sound, all of which are areas of expertise for the animator. The relationship between illustrator and animator is important, for they have to work closely together to end up with a stylistically coherent film.

When all the basic drawings have been worked up to a relatively finished degree, a line test is made. This is a film of the basic drawings shot in sequence so that the overall movement of the animation can be clearly seen. It is at this stage that amendments can be made and that a client can see for the first time how the finished film will look. The colouring of the cels takes place after this stage has been passed.

Below Illustrator as animator. Arthur Robins is best known for his editorial and children's book work, but his quirky, cartoon-like style adapts extremely well to animation. His characterful work can hold its own without the support of a detailed background. He has done the master drawings, and these have then been animated by a studio.

STORYBOARDS

Illustrators are often commissioned to storyboard concepts and ideas for advertisements that will be finally filmed with real people. These storyboards are prepared to sell the idea to the client and to give a notion of the look of the advertisement. The style varies, but the agency is always looking for a sophisticated evocation of its concept. An illustrator's drawings can set a cinematic mood and be a guide to the lighting and atmosphere. Often an "animatic" will be made of these drawings – that is, they are put on video so that they become a "moving" storyboard.

Right Classic, Disney-style animation, with extremely detailed backgrounds setting off the main characters, was used in this 30-second television commercial. An astounding amount of work in storyboarding and animation goes into even short advertisements.

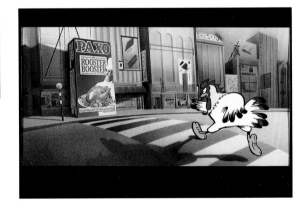

Below This use in this television commercial for SwissAir of simple black and white line work with just a red plane not only makes an arresting and unusual advertisement but also echoes the company's corporate image. Sometimes a simple approach is refreshing, especially at a time when computer animation can achieve so much that it is difficult not to go "over the top".

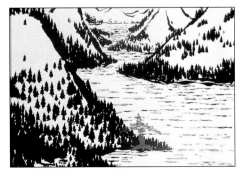

An extremely successful animated advert for a ferry company. The drawn style, originally created in pastels by Mike Bennallack-Hart, is faithfully animated without losing its inherent qualities. This animation process took 16 weeks.

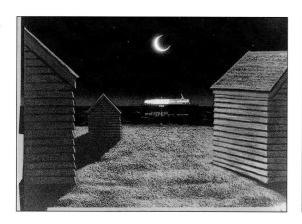

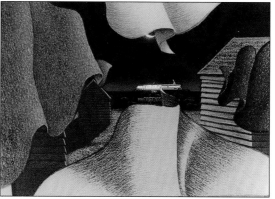

Animation

SINCE GENE KELLY first danced with Jerry Mouse, animation has mixed well with live action film – this advertisement for Casio synthesisers is an excellent example. The genesis of the advert was straightforward enough. A rough idea of the ingredients was worked out a Doremus & Co., a New York advertising agency, and art director Lori Lum did some basic roughs of an animated character springing forth from musician Herbie Hancock as he plays the synthesiser. The intention was to shoot him using the "ultimat" process, which would isolate the figure of Herbie Hancock, and to have either a blank or an animated background. When One Point Five were commissioned to bring the concept to life, they decided to shoot against a simple studio backcloth. Rather than just working with the two flat planes of Hancock and the animation, a backdrop would make the end result more three-dimensional in appearance. It also gives a very classy look to the advert. The storyboard was meticulously planned and the animation designed before any film was shot. When the studio shoot of Herbie Hancock was completed in Los Angeles, it was roughly edited (on film) and a bromide was made of every frame, to enable the animation to be done.

Right The roughs, developing the characterizations, were created by illustrator Lin Jammet, based on Lori Lum's originals. He refined the musical elements that make up the character that springs to life from Herbie Hancock.

Right The storyboarding for a mixture of animation and live action is critical, and needs to be thorough and accurate. This is part of a presentation storyboard to convey the basic look of the commercial to the client.

Right Three of the cels that form the animation. Once Lin Jammet had drawn the key frame illustrations, the in-betweens were painted by as many as twenty different people.

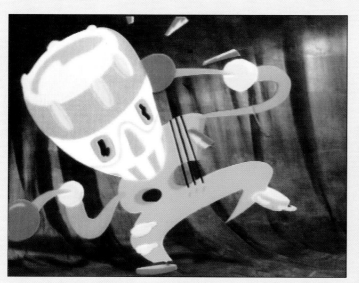

Left and below Two still frames from the finished advert, showing how the integration of animation and live action works. Recently, American agencies have turned to British companies for the combination of illustration and technical expertise.

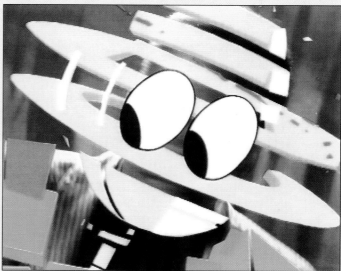

CASE STUDY

Animation

THE NEW YORK advertising agency Young & Rubicum had gone to Ink Tank (an animation studio) with the idea of working with British illustrator Arthur Robins on a commercial for the US Postal Service. Y & R showed Ink Tank examples of Arthur's work, including the Actifed commercial, page 120, and suggested that Ink Tank use him as the designer/illustrator on the US Postal job. Y & R liked Arthur's work because of his sense of, and attention to, detail, his "humanization" of objects and concepts, and his approachable, "entertaining" drawing style. The Ink Tank animation studio, says J.J. Sedelmaier, producer of the ad, "has a similar reputation. R.O. Bleckman

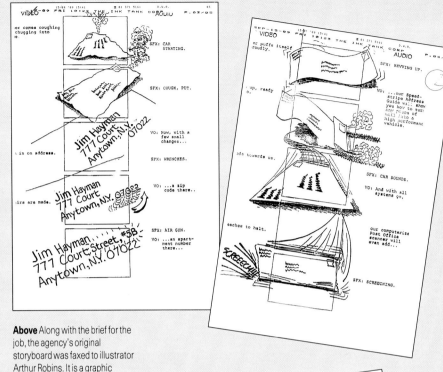

Above Along with the brief for the job, the agency's original storyboard was faxed to illustrator Arthur Robins. It is a graphic treatment of the script, lacking character.

Right Arthur's storyboard uses the same script, but with a much more coherent approach. Every situation is given a witty twist or location, such as the use of Benjamin Franklin on the stamp and the desert landscape.

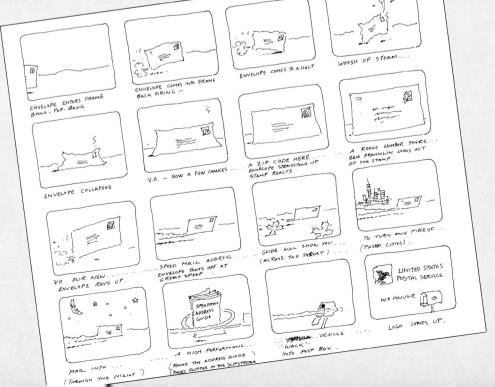

D.L.Ricci Corp.

ON-SITE MACHINING EQUIPMENT
SALES & RENTAL
TEL: 01663-746600 FAX: 01663-746611

Left Three enlarged details from the storyboard showing the style and the Benjamin Franklin character. Arthur, knowing how the Royal Mail would not allow the Queen's image to be tampered with in any way on a stamp, is unsure that the US Postal Service will agree to his idea.

Below A colour rough of the envelope to be shown to the client for final stylistic approval.

Below The storyboard, complete with Benjamin Franklin idea, is approved. Here, after the Ink Tank's animation work, is a frame from the finished film, extremely faithful to Arthur's original drawings.

(whose work is heavily featured in magazines such as *The New Yorker*) is the director of the studio and designs 30–40 per cent of Ink Tank's work. The rest is made up of illustrators that agencies approach us with, or that Ink Tank sees and considers perfect for the project it's working on." Ink Tank has worked with illustrators like George Booth, Maurice Sendak, George Price, Lee Lorenz and Gary Baseman. When Ink Tank works with illustrators it offers as much input as the designer wants – there is no formula.

SECTION FOUR

PRODUCTION AND PRINTING TECHNIQUES

Production and technicalities

ONCE YOU HAVE DESIGNED the project and have all the artwork and layouts in your hands, it is time to produce the final package, a process that involves the physical putting together of these elements in readiness for printing.

Publishers, advertising agencies and design groups have specialist production staff or departments that are responsible for devising schedules for each project. This will be a timetable of the deadlines for each stage: when the text should be handed in, when the illustration is needed, when the typesetters have to deliver the type. The production department also liaises with the printer, and, in general, acts as the art director's right-hand person throughout the entire process.

Sometimes, with letterheads or small brochures, for example, the art director acts as his or her own production department and will also probably prepare the artwork.

As an art director you should know as much as possible about the production and printing side of the operation. Although you can rely to some extent on the advice of your contacts at the printers and typesetters, the more you know, the more you can get out of the techniques they have at their disposal. Keeping abreast of the latest developments and learning how to use and exploit them will ultimately give you greater control over the finished product. It is also important to know what is and is not possible, because chasing after impossible ideas can be a tremendous waste of time.

Circumstances vary, of course, but in general production and printing follow a similar pattern in all the fields of art direction. There are certain potential problem areas to which you should be alert whatever the project.

SIZING

ILLUSTRATORS RARELY WORK to the finished size of a job. The artwork will be larger, usually by 50 per cent. This is a practical consideration, as reducing for print is usually believed to improve an image. From the illustrator's point of view, too, it can be difficult stylistically to work to a small scale.

Technically this means that when the image is scanned on to film, the scanner will be instructed to reduce the artwork by a given percentage. How you size the image is therefore important. You must be as accurate as possible when indicating where and at what size the illustration will appear. An error of only 1 or 2 per cent either way can make a con-

Below Production schedules vary from project to project, but they basically set out the dates for delivery and completion of the various elements and stages of a project.

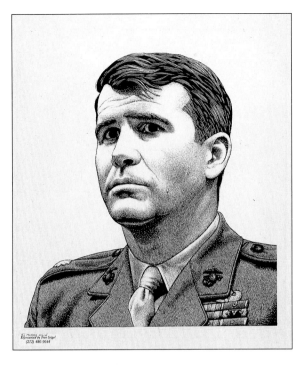

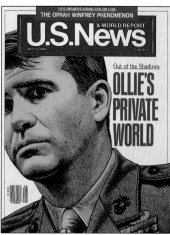

Left An example of how bold cropping turns a graphically strong, but straightforward, illustration (by Mirco Ilic) into a striking magazine cover. The tilt of the image lends dynamism, and the way the illustration bleeds off the left-hand-side gives added focus to the right eye. The use of a red tint completes the designer's transformation of the drawing.

siderable difference. It is often a good idea not only accurately to trace the illustration into place, but also to put the major measurements on your layout.

If you are working on a computer screen and inputting the text and illustrations yourself, sizing is straightforward.

CROPPING

ALWAYS TRY TO ENSURE that the illustration is cropped exactly as you and the illustrator intended it to be. If the finished artwork has a ragged-edged bleed of 5mm outside the trimlines, it is always possible that it will be wrongly cropped during the process of colour separation. Slight inaccuracies are bound to occur whether you indicate the position of the illustration on your finished layout by using a trace done on a copiscanner or visualizer, by pasting down a photocopy or by simply drawing a shape. You should also allow for your illustrator's set

square not being square! Keep a special watch if the illustration has to bleed off one edge of a page, as it can be crucial not to lose too much of the image.

Even if, in the end, discrepancies are noticed only by you, it can be incredibly annoying to have spent weeks, or even months, on a project, only to have the finished result spoilt because the type is too close to the illustration by 2mm.

Above Illustration for a book cover. This shows how much space was left on the artwork for a bleed area and how the final book-cover shape was imposed.

Transparencies and colour reproduction

THE BEST SIZE FOR A COPY TRANSPARENCY of artwork is either 10×8in or 5×4in. The larger size is much more expensive, so most people use the standard 5×4in. The advantages of these large-format films are the fine grain and high-quality results they offer and the fact that, as they are sheet films, photographers can shoot one picture only rather than having to use a whole roll of film on a single piece of artwork.

Photographing flat or three-dimensional artwork is skilled work. The lighting is crucial, and some illustrators use the same photographer regularly if

Examples of a 2¼ in **(below)** and a 5 in × 4 in **(right)** colour transparency, taken from flat artwork.

they do the sort of work that often requires a transparency. It is worth finding a photographer or studio that you can trust to handle this sort of work, as mistakes are costly in time and money. If the colour is not accurately copied onto film, it is more difficult for the printers to match the colour to the original artwork.

COLOUR REPRODUCTION

EVERYONE HOPES THAT THE COLOUR of the artwork will be reproduced as faithfully as possible, and today's machines are extremely precise. The crucial person in accurate colour reproduction is the oper-ator of the scanner, who is responsible for analysing the colour material he or she is working with and whose trained eye decides how best to set the machine to read the image.

The basic process starts with the input scan. The colour artwork that you hold in your hands is attached to the laser scanner's large cylinder. If it will not bend around the gentle curve of the cylinder, is more than 2mm thick or is too large for the cylinder, you must have a transparency made.

Once it is on the scanner, light is reflected back from the cylinder through the transparency and recorded on disk; if artwork is used, the light is reflected off its surface. The scanner breaks down the information from the illustration into the four process colours. The disk is taken to the page make-up tables, where the illustration is planned up on screen and into place in the layout. The four films, each carrying one colour – cyan (blue),

magenta (red), yellow and black – are then outputted, and when these four versions of the same image are printed together, full colour results.

Some colours are difficult to match accurately; deep blues, gold, orange and certain shades of pink present problems for colour reproduction. This should not prevent them being used by illustrators (indeed, packaging orange juice might be a problem if you decided to avoid them), but you should be aware that the end result will not quite match the original.

Left: A scanner operator putting a transparency onto a laser scanner cylinder. The accuracy and quality of the scan is a crucial factor in the colour reproduction process.

Left and below Progessive proofs taken from separated colour films, showing how the four-colour result is built up in stages. The sequence in which the set is built up can vary from one repro house or printer to another.

Overlays, tints and separations

ILLUSTRATIONS THAT REQUIRE OVERLAYS fall into two categories.

You may have commissioned an illustrator to do a piece of work that you or your art department needs to put information on. This could be a drawing of a street scene that has to be numbered and keyed, with most of the information printed as a caption beside the illustration. This process is fairly straightforward: the type and numbers are placed on an overlay, which is easier for the printers to work with. They do not want the numbers stuck down on the illustration as they would be unnecessarily separated into four colours. The printers want a clean piece of film with all the numbers ready to overprint in a specific colour.

More complex work demands a different approach and one in which the illustrator is responsible for dealing with all of the elements. This might be a complicated map with detailed information that has to appear within the illustration itself or a chart that is basically text and only partly illustration. You would probably commission an illustrator who specializes in combining information, type and images. The text is such a fundamental part of a job like this that the illustrator becomes the designer and provides artwork that already contains text overlays.

Right The parts of this illustration that print in a second colour of gold have been separated from the artwork and drawn on a film overlay. This saves the printer having to do the separation, but more importantly, leaves less room for misinterpreting instructions.

Above An essential tool of the art director's trade is a colour-specification system. Specifying a colour for a tint panel, a tint overlay, or a flat-colour screen print is impossible without using one. Illustrated here is the widely used PANTONE®* system. Always check that the printer you're working with (especially if unfamiliar) is using a compatible system.

*Pantone, Inc's check standard trademark for colour reproduction and colour reproduction materials.

Overlays can also be used to separate the colour used in an illustration. A piece of artwork may be supplied that consists of the base artwork, which prints black, and three overlays, one for each of the separation colours.

When the four-colour system is not used, overlays can be supplied with instructions to print specified Pantone colours or percentage tints. How these tints will print and what colours will result is often a matter of trusting the illustrator's experience, and, indeed, your own.

Right The colour separations, created on coloured tone films, of the illustrations shown on page 89. Using these films not only keeps the colour strong and clean, with defined sharp edges, but also allows the exact colour of the finished job to be seen. This cleanness of colour is especially important when a wide palette is used and shows the advantage in certain circumstances of using mechanical tints instead of hand colouring.

Proofing

PROOFING IS THE STAGE in the process at which you see all the elements together as they will appear in the finished result. Most jobs have one colour proofing stage, but very complicated work may require further proofs. The more proofing stages you have, the more expensive the job will be. The number of colour proofs that you receive depends on the process. Cromalin proofs, which are made by a

Above Checking a colour proof in a viewing booth. The transparencies of the artwork are on the lightbox to the right so that the designer can refer back and forth between original and proof.

photographic process, are expensive, and usually only two are made, one for you and one for the printer's reference. Wet proofing, by which sheets of paper are printed on a proofing press, will give you as many as ten or twelve copies.

The first proofs you get will usually be black and white photocopies, or Ozalids, taken from the text film and one of the colour separations. As no colour proofs will yet have been made, it is quite easy to make adjustments. You can, with a reasonable degree of accuracy, check that the illustrations and the text are in the correct places. The colour separation chosen for this stage is the one that shows the most detail of the image (usually this is the blue film). If the illustration is incorrectly placed, the colour separators will move all four films accordingly.

Checking colour proofs is best done in controlled conditions, using a viewing booth, which gives a neutral, even light. Colour separation houses have these booths, and regular clients who do a large amount of colour proofing will have booths built and lit to the same specifications. This is so that any instructions you make to change any elements of colour on the proof can be assessed by the colour separators under exactly the same conditions.

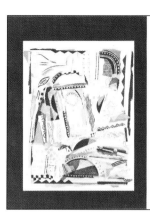

Left An Ozalid proof. This is usually the final stage before a colour proof is made and allows for any corrections to the placement or wording of the type. The colour films are sandwiched together and registered, and a process not dissimilar to photocopying results in an Ozalid.

Below A Cromalin proof and the printed spread as it appeared in a magazine. Cromalins are made on a very white material, which can be sprayed with matt varnish to approximate the paper stock used. However, in this case the magazine is large-circulation (700,000) and consequently printed on fairly coarse paper and therefore the images look less sharp and bright than on the Cromalin.

Above Colour corrections marked on a Cromalin proof. At this stage the image can still be moved to align with the type, and small mistakes (the depth and width of the red bar) corrected.

Printing

YOU USUALLY KNOW AT THE OUTSET of a project the method that will be used to print the finished result. Indeed, this may have affected your choice of illustrator. If you have the facilities to print in black line only, you must decide if you want the harsh drop-out effect that pencil has when printed this way or if you would rather use someone who works in pen and ink. If the paper stock on which you are printing is very rough, a subtle, detailed illustration will lose impact. And you would not use an illustrator who works on a Paintbox computer if you are going to print the finished result by letterpress.

As with the separation process, the more knowledge you can accumulate about printing, the more confident you will be about how your project will look when finally printed.

INSTRUCTING THE PRINTER

Be as clear and concise as you can when writing instructions for the printer. Think about what you want to say and the best way of saying it before you write anything on the layout or on the overlay. It is both expensive and time-consuming to have to re-scan an image or to change the layout in any way once it has been committed to film, so if there is any instruction that you are unsure of, phone the printer and discuss it. It wastes their time as well as yours if they misunderstand you. In time, as you work with one separation house or printer regularly you will develop a shorthand way of writing your instructions, as you find out what terms they use for different jobs.

CUT-OUTS AND BACKGROUNDS

Artworks are not always squared-up images. When they are scanned the tone of the paper or surface on which the illustrator has worked appears in a squared-up shape around the image. To achieve a cut-out or "free-floating" look, you have to instruct the scanner operator to drop this background tone to white; always use a trace to show exactly which areas you mean. The machine will be instructed to drop the minimum tone that results from the original surface. If you want to print a free-floating

Below This is the trace overlay showing the printing instructions for the illustration by Clive Piercey featured on page 89. Precise instructions are incredibly important when dealing with this number of separate elements and overlays.

image on a black or coloured background, it is more likely that the area surrounding the image will be masked or painted out by hand rather than being done on the scanner.

PRINTING ON COLOURED PAPER

This is a technique to use with subtlety. The colour balance of a colour illustration will be shifted if the paper underneath it is coloured. A light colour – cream or pink, for example – will not have much effect, but anything darker can cause complications. It is impossible to have a colour proof such as a Cromalin done on coloured paper, but wet or signature proofing can be done on the actual paper the job will be printed on. However, as this is done at quite a late stage in the process, you must be absolutely certain right from the start that you want

coloured paper and that the technique and style of the illustrator will suit this. Printing black or even white on coloured paper is a much more straight-forward proposition as there is no colour balance to shift.

This page A set of prints and a folder advertising paper stock. All of the colour images have been made up from simple line drawings (**right**) but with different colour printing instructions. You can see from the three versions of the parrot illustration how varied the effects of colour can be.

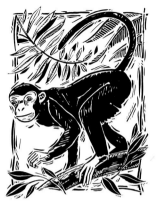

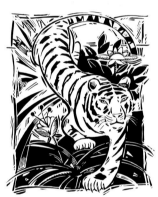

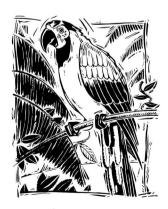

Index

S

Saddington, Lesley, *33*
sales directors, book
 publishing, 70, 71
Salmon, Tabitha, 18, *19*
Sanderson, Bill, *8*, 31, *62*
Saunders, Rosanne, *93*
scanners, 130, 132-3, *133*
Scarfe, Gerald, 68
schedules, 49
 magazine illustration, 64
 production, 130, *130*
scraperboard, *8*, 31, *31*, *62*
Scullard, Sue, *30*, 102, *102-3*
Sedelmaier, J.J., 126
Sendak, Maurice, 127
separation, colour, 83, *135*, 136
serial rights, 52
shops, carrier bags, *12*, *23*,
 100, 106
silkscreening, *96*
Silmon, Pedro, *54*
Simpson, Kate, *11*
size of illustrations, 48, 130-1,
 132
sketches, fashion
 illustration, 106
Slater, Paul, *20*, *28*, *54*
Smarties, *121*
Smith, W.H., *12*
Snow, George, *23*, *33*
Sobr, Penny, *107*
source books, 44, *44*
Soviet Union, 18, *19*
specialisation, 38
statistics, diagrams, 88, *88-9*
step-by-step illustrations, 21
still lifes, 18-19
stock illustrations, 43
Stocks, David, 94, *94-5*
storing artwork, 136

storyboards, animation, 120,
 121, *124*, *126*
students:
 degree shows, 41, *41*
 interviews with art
 directors, 39
style and approach, 22-35
Sunday Times, 69
Sunday Times Magazine, 28,
 54, *83*
Suter, David, *68*
SwissAir, *122*
syndication departments, 52

T

T-shirts, 107
tear sheets, 40
technical illustrations, 80, 84,
 84-5
telecommunications, 45
television, 118, *118*, *122*
Terry, Michael, *19*
text overlays, 134-5
3i, *59*
thumb-nail sketches, 55
Thunderjockeys, *33*
tints, 135, *135*
Toft, Hannah, *108*
Tohato Confectionery
 Corporation, 104, *104-5*
trace overlays, *138*
transparencies, 32, 52, 132,
 132, 136
travel expenses, 50
travel illustrations, 19-20
Traveler, *85*
Trickett, Lynn, 78-9, *78-9*
Trickett & Webb, 78-9, *78-9*
typesetting, 82, 130
typography, 59, *59*, 82

U

US Postal Service, 126, *126-7*
USSR, 18, *19*

V

Van Allsburg, Chris, *75*
Van Dooren, Dirk, 114-15,
 114-15
Vicky, 68
videos, 118
vignettes, *41*
visualizers, 131

W

War on Want, *116*
Washington, George, *65*
watercolours, *9*, *23*, *24*, *26*, *27*,
 64, *65*, *91*
Way, Steve, *68*
Webb, Brian, 79
Weisbecker, Philippe, *117*
West, 65
wet proofing, 136, 139
Williams, Colin, *25*, *112*
Wind in the Willows, *11*
wine labels, *101*
Wood, Tom, 97
woodcuts, 30, *30*, *109*
Woodward, Fred, 66, 67
world rights, 52
Wormell, Christopher, *109*

X

Xerox, *32*

Y

year books, illustrators, 44, *44*
Young & Rubicum, 126

CREDITS

Quarto would like to thank the following for their help with this publication and for permission to reproduce copyright material. Every effort has been made to trace and acknowledge all copyright holders. Quarto would like to apologize if any omissions have been made.

Abbreviations T Top; **B** Bottom; **C** Centre; **R** Right; **L** Left; **lll** Illustrator; **AD** Art Director.

p 8 Bill Sanderson (**lll**) Martin Colyer (**AD**) for *The Listener*.
p 9 **L** Michael Frith for *Sunday Times London Magazine*; **TR** & **BR** Hannah Tofts (**lll**) Valerie Pidgeon (**AD**) for Pandora Press.
p 10 **TL** Peter Brookes (**lll**); **BL** Robin Jacques (**lll**) Greg Martin (**AD**) at Abbot Mead Vickers for Volvo; **R** Mark Harfield (**lll**) for The Frame Store.
p 11 **L** Ken Hogg (**lll**) for London Playday; **R** Kate Simpson (**lll**).
p12 **TL** Dirk van Doren (**lll**) The Senate (**AD**) for Penguin Books; **BL** Geoff Appleton (**lll**) James Beveridge (**AD**) at The Partners for WH Smith; **R** Tim Moore (**lll**) for the National Theatre.
p 13 **L** Jonathan Inglis (**lll**); **TC** & **R** Paul Davis (**lll**) for Epigram; **BC** B.M.P. Davidson Pearce for War on Want.
p 16 Mike Terry (**lll**) for Whitbread & Co.
p 17 **TL** & **TR** Julian Allen (**lll**) for *Mail and Female Magazine*.
p 18 **T** & **B** Bush Hollyhead (**lll**) for Picador.
p 19 **T** Tabitha Salmon (**lll**); **B** Mike Terry (**lll**); Mike Davets (**AD**) for Qantas Airlines.
p 20 **T** & **B** Paul Slater (**lll**) for Pluto Press.
p 21 **T** & **B** Geoff Grandfield (**lll**) for Pan Books Ltd.
p 22 Melissa Grimes (**lll**) for *Regardies Magazine*.
p 23 **TL** Enoke Bakti (**lll**) of The Organization for Zodiac; **TR** & **CR** Claudio Munoz (**lll**) for the *Observer*; **BR** George Snow of Sharp Practice (**lll**).
p24 **TR** Clare Jarrett (**lll**) for *New Statesman and Society*; **B** Claudio Munoz (**lll**) for the *Observer*.
p 25 **TL** Clare Jarrett (**lll**) for *New Statesman and Society*; **TR** Colin Williams of Young Artists (**lll**); **BR** Colin Williams (**lll**); David Crow (**AD**) of Island Art for Island Records.
p 26 **L** Chris Brown (**lll**) Charlie Stebbings (Photo) Abbott Mead Vickers (**AD**) for Rimmell International; **R** Amanda Hutt (**lll**).
p 27 **TL** & **TR** Michael Frith (**lll**) for *Sunday Times London Magazine*; **BR** & **BL** David Holmes (**lll**) Holmes, Knight and Richey (**AD**) for Common Ground.
p 28 **TL** Lynda Gray (**lll**) Bruno Tilley (**AD**) for Island Records; **BL** Kate Simpson (**lll**); **R** Paul Slater (**lll**) for the *Sunday Times Magazine*.
p 29 **T** Tom Stimpson (**lll**); **B** Terry Collins for Ford.
p 30 **L** & **BR** Edwina Ellis (**lll**) for Faber & Faber; **CR** Sue Scullard (**lll**) for *The Folio Society*.
p 31 **T** Bill Sanderson (**lll**) Martin Colyer (**AD**) for *The Listener*; **B** Leonard McComb (**lll**).
p 32 **R** Darrell Rees (**lll**); **CT** Mark Harfield (**lll**); **CB** Enoke Bakti (**lll**) of The Organisation for La Poterie; **BR** Lesley Saddington for the *Sunday Times Magazine*.
p 33 **L** Andy Martin of Sharp Practice (**lll**); **TR** Thunderjockeys (**lll**); **BC** George Snow of Sharp Practice (**lll**); **BR** Thunderjockeys (**lll**).
p 40 Benoit Jacques (**lll**).
p 41 **TR** & **TL** Peter Forster (**lll**); B Helen J. Holroyd (**lll**) for Brighton Illustrators' Group.
p 45 Stuart Robertson (**lll**).
pp 46/47 Simon Roberts (**lll**) Tony Paine (**AD**) for British Waterways.
p 49 **TL** & **TR** Neil Shakery (**AD**) for Pentagram USA. **B** Michael Hodgson and Clive Piercey (**lll**) Phd (**AD**).
p 51 Chloë Alexander (**lll**) (**AD**) for John Lewis plc.
p 54 **RC** & **L** Paul Slater for *Sunday Times Magazine*.
p 55 Ann Savage (**lll**).
pp 56/57 Graham Rosewarne (**lll**) Nick Buzzard (**AD**) for Quarto.
p 58 Graham Rosewarne (**lll**) Nick Buzzard (**AD**) for Quarto.
p 59 Richard Adams (**lll**) Mark Reddy (**AD**) for 3i.
p 62 **R** & **C** Ed Briant (**lll**) Mike Lackersteen (**AD**) for *Marxism Today*; **R** Bill Sanderson (**lll**) Martin Colyer (**AD**) for *The Listener*.
p 63 **CL** & **BL** Peter Sullivan (**lll**) for *The Straits Times*; **TR** Christina Rendina (**lll**) the Senate (**AD**) for Penguin Books; **BC** & **BL** Geoff Grandfield (**lll**) for Serpent's Tail.
p 64 **L** & **R** Anita Kunz (**lll**) for the *Boston Globe Magazine*.
p 65 **TL** & **TR** Mirko Ilic (**lll**) Fran Seigel (Agent) reproduced with permission from MONEY © Sept. 1988; **BL** Paul Cox (**lll**) for *Blueprint* magazine; **BR** Gary Baseman for *West* magazine.
pp 66/67 All pix Philip Burke for Rolling Stone magazine.
p 68 **L** David Suter (**lll**) **R** Steve Way (**lll**) for the *Observer*.
p 69 **L** Chan Chee Kin for *The Straits Times*; **R** Davbid Bromley for the *Sunday Times*.
p 70 **L** Coronet Books; **R** Sue Scullard (**lll**) for Faber & Faber Ltd.
p 71 **L** Accident (**lll**) for Penguin Books; **R** & **B** Amanda Hutt (**lll**) for Serpent's Tail.
p 72 **TL** Chloë Cheese (**lll**) from *Desserts and Pastries* © 1988 by Anne Willan for Walker Books Ltd.; **TR** Robert Shackleton and Richard Baker (**llls**) the Senate (**AD**) for Penguin Books; **B** Ian Millar (**lll**) Steve Kent (**AD**) for Bloomsbury Publishing Ltd.
p 73 **TC** & **TR** Transworld Publishers Ltd.; Peter Knock (**lll**) for Sphere.
p 74 **T** & **L** Ian Beck (**lll**) for Conran Octopus.
p 75 **TL** & **BL** Chris van Ahlsberg (**lll**) for Andersen Press, 62/65 Chandos Pl. London WC2; **TR** & **BR** Michael Heath (**lll**) for Chatto and Windus.
pp 76/77 All pix Ian Beck for Penguin Books.
pp 78/79 Miles Aldridge (**lll**) Lynn Trickett (**lll**) for Bloomsbury.
p 80 Grundy Northedge for the D.T.I.
p 81 **TL** Penny Sobr (**lll**) for Cosmopolitan; **C** Line and Line (**lll**).
p 83 Line and Line (**lll**) for the *Sunday Times*.
p 84 **L** The New Small Gardens Book by John Brookes, published by Dorling Kindersley; **R** Terry Collins (**lll**) for Ford.
p 85 **B** John Grimwade (**lll**) for Conde Nast *Traveler* magazine.
p 87 **TL** & **R** Helmut Jacoby (**lll**).
p 88 **BL** Grundy Northedge (**lll**) **TR** Diana Hoare (**lll**) for Pollock and Searby Publishing.
p 89 Clive Piercey (**lll**) Phd (**AD**).
p 92 Don Cordery Folio (**lll**).
p 93 Brigid Edwards/Folio (**lll**); **BR** Rosanne Saunders (**lll**) Robinson Lambie-Nairn (**AD**) for The Boots Company.
pp 94/95 Grundy Northedge (**lll**) David Stocks (**AD**) for Michael Peters Literature.
p 96 Mark Harfield (**lll**) for The Frame Store.
p 97 **L** Tom Wood (**lll**) for London Underground Ltd; **TR** & **TB** Rob Cochrane for Lip International.
p 98 All pix Chris Brown (**lll**) Charlie Stebbings (Photo); Abbott Mead Vickers (**AD**) for Rimmel International.
p 99 **T** Robin Harris (**lll**); **BL** Olivia Beasley (**lll**) Russell Waldron (**AD**) John Canning (Writer) Allen Brady & Marsh (Agency) for the Welsh Food Initiative; **BR** Simon Stern of Sharp Practice (**lll**) for Air Canada.
p 100 **T** Lucilla Scrimgeour (**lll**) Lewis Moberly (**AD**) for Boots; **BR** & **BL** Geoff Appleton (**lll**) James Beveridge (**AD**) for W.H. Smith.
p 101 **L TR** & **BR** Faranak (**lll**) Carroll Dempsey and Thirkell (**AD**).
pp 102/103 All pix Sue Scullard (**lll**) Chloë Alexander (**AD**) for Waitrose Ltd.
pp 104/105 All pix Isabelle Dervaux (**lll**) Sophie Le Fevre (**AD**) for the Tohato Confectionery Corporation of Japan.
p 106 **L** Tony McSweeney (**lll**) BMP DDB Needham (**AD**) for International Wool Secretariat; **R** David Hiscock (**lll**) Young & Rubicam (**AD**) for Mansfield Clothing Co.
p 107 **L TR** & **BR** Penny Sobr (**lll**) for Charles of the Ritz and Dupont.
p 108 **C** John Lawrence (**lll**) Minale Tattersfield (**AD**) for NatWest Bank; **B** and **R** Hannah Tofts (**lll**) Fine White Line (**AD**) for IBM.
p 109 **TR** Chris Wormell (**lll**) Sedley Place Design Ltd (**AD**) for Egerton Trust; All other pix Paul Davis (**lll**) for Epigram.
pp 110/111 George Hardie (**lll**) Mark Reddy (**AD**) for Holmes Knight & Ritchie.
p 112 Colin Williams (**lll**).
p 113 **T** Phd (**AD**).
pp 114/115 Dirk Van Dooren (**lll**) Ann Bradbeer (**AD**) for Decca Records.
p 116 **L** B.M.P. Davidson Pearce for War on Want; **C** Martin Huxford (**lll**) for Handmade Films.
p 117 **T** & **BL** Bush Hollyhead (**lll**) Steve Hudson (**AD**) at HDM Horner Collis, Kirvan for Taboo & Mirage; **BR** Phillipe Weisbecker (**lll**) for Trickett and Webb/Augustus Martin.
p 118 **T** Graham Kern at BBC (Design) CAL Ltd. (3D design).
p 119 **TL** Graham Kern at BBC (Design) CAL Ltd (3D animation); **TR** & **CR** Rhythm and Hues Inc. for Sunbeam Express Meals; **BR** & **BL**.
p 120 **L** & **R** Arthur Robins (**lll**) Maggie Mullen Productions (**AD**) for Actifed Cough Syrup.
p 121 **L** Arthur Robins (**lll**) Maggie Mullen Productions (**AD**) for Actifed Cough Syrup; **TR CR** & **BR** Snapper at MGMM via J Walter Thompson for Rowntree Mackintosh.
pp 124/125 Lin Jammet (**lll**) Joe Wattleworth (**lll**) for Casio.
p 126/127 Arthur Robins (**lll**) for US Postal Service.
p 131 **TL** & **TR** Mirko Ilic (**lll**) Fran Siegel (Agent) for U.S. News and World Report.
p 132 **BL** Miles Aldridge (**lll**) **BR** Hannah Firmin (**lll**).
p 133 **B** Cathie Felstead (**lll**).
p 135 **B** Clive Piercey (**lll**) Phd (**AD**)
p 138 Clive Piercey (**lll**) Phd (**AD**)
p 139 Jo Lawrence (**lll**) McCann Erikson (**AD**) for G-P Inveresk Ltd.

Author's Acknowledgments

Thanks to Mark Reddy, Michael Hodgson and Clive Piercey, Ivan Bullock, Pedro Silmon, Bob Simpkin, Andrew Kay, Catherine Caldwell, Tilly Northedge and Peter Grundy, Philip Burke, Arthur Robins, Dennis Kendrick, Simon Esterson and Mike Lackersteen, George Hardie, Lynn Trickett, Steve England, Michael Bartalos, Isabelle Dervaux, Paul Cox, Ann Bradbeer, Andrew Mockett, Tabitha Salmon, J. J. Sedelmaier, Miles Aldridge and Dirk van Dooren. Thanks also to art directors and editors I have worked with – David Driver, Russell Twisk and John Tennant. Special thanks to my wife, Michele.